# MILFORD

# MILFORD

## A BRIEF HISTORY

### FRANK JULIANO

Charleston · London

THE
History
PRESS

Published by The History Press
Charleston, SC 29403
www.historypress.net

*Front cover image, top*: Memorial Bridge in 1910. *From the Henry "Buster" Walsh Postcard Collection.*
*Front cover image, bottom*: Island View Hotel. *From the Leroy Roberts Photograph Collection, used with permission of the Thomas J. Dodd Research Center, University of Connecticut.*

First published 2010

Manufactured in the United States

ISBN 978.1.59629.924.5

Library of Congress Cataloging-in-Publication Data

Juliano, Frank A.
Milford : a brief history / Frank A. Juliano.
p. cm.
Includes bibliographical references.
ISBN 978-1-59629-924-5
1. Milford (Conn.)--History. 2. Milford (Conn.)--Biography. I. Title.
F104.M7J85 2010
974.6'7--dc22
2010008858

*Notice*: The information in this book is true and complete to the best of our knowledge. It is offered without guarantee on the part of the author or The History Press. The author and The History Press disclaim all liability in connection with the use of this book.

*For my father,*
*Frank A. Juliano Sr.,*
*1923–2002*
*He shared with me his love*
*of history and of America*

# CONTENTS

# CONTENTS

# CONTENTS

# PREFACE

When my wife Nancy and I decided to move to Milford in 2002, we were following a pattern that had begun thousands of years earlier. Archaeologists have found a projectile point here dating back to the Paleolithic period—more than six thousand years ago. A clay pipe found in the Indian River has been carbon-dated to about 1000 AD, known to archaeologists as the Late Archaic period.

The Paugussett Indians who were here when the original European settlers arrived in 1639 were themselves descendants of a people who had hunted, fished and made their homes for hundreds of years along the four rivers that flow through Milford. In later years, as the Housatonic River estuary was dredged, workers found shellfish middens forty feet deep. Milford's first residents, like we do, enjoyed the bountiful oysters and clams.

Consider this: by the time the present United States government was formed under the Constitution in 1789, Milford was already 150 years old. It may have been part of a new nation, but the people who lived in Milford already had deep roots. Look up the names of present-day residents and you'll find many with the same surnames as the first "founding" families. They are still here—why would they leave?—for the same reason you and I are.

But you will also find among Milford residents Chinese, Saudis, Vietnamese, Thais, Portuguese, Brazilians, people from nearly all of the regions of India and natives of many other countries. The public schools' English as a Second Language program serves speakers of fifty-one different languages.

For millennia, people have chosen to live and raise their families here because of the land—gently sloping toward the water—the abundance of fish and fowl, the sweeping vistas and the spectacular natural beauty. And

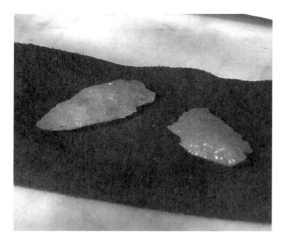

These projectile points were fashioned of milky quartz and used by Paugussett Indians before or shortly after English settlers arrived in 1639. They were found near Gulf Pond and are part of the Milford Marine Institute collection. *Courtesy of Tim Chaucer.*

This larger Paugussett projectile point was found near Gulf Pond and is part of the Milford Marine Institute collection. *Courtesy of Tim Chaucer.*

in recent years, people have also been attracted to Milford's quaint New England charm. As the city has grown, it has maintained its white-steepled Congregational church, the central Green, the historic saltboxes of the early settlers and the gracious homes of Victorian movers and shakers.

That's not to say that this place is frozen in time (except for the Upper Duck Pond in winter). One of the region's largest fuel-cell companies is located here, along with a firm that makes astronaut helmets for NASA and the franchiser that turned a sandwich into a work of art.

So if you are here for the day or the weekend—or, like Nancy and me, you found yourself spending so much time in Milford that it made sense to buy a house and unpack your stuff—welcome.

# ACKNOWLEDGEMENTS

Nobody writes a book like this without a lot of help, and Milford is blessed with many people who cherish its history. I have especially benefited from the assistance of Richard N. Platt, the municipal historian, who once taught history at the high school I attended. I did not take any classes from him then, but I have learned a lot from him since coming to Milford.

Timothy Chaucer, the executive director of the Milford Marine Institute and the Gulf Pond Museum, has always been generous with his time and in allowing his many Indian artifacts to be photographed and written about. His obvious enthusiasm for not only history but also ecology, birding and other wildlife makes every conversation with him interesting.

I have also been helped in my study of local history by Gerard Patton, the founder of the Milford Hall of Fame, which honors prominent residents from each of the five centuries that the community has existed. Patton also heads the Milford Rotary Club's oral history project, recording the memories of older residents; several of the videos in this series helped in my research.

Ardienne Damicis and Susan Carroll Dwyer of the Milford Historical Society, Barbara Genovese of the Milford Historic Preservation Trust and the ladies of the Daughters of the American Revolution—particularly Lujan Fenton, Edna Luysterborghs and Sheila Beirne—have been especially helpful to my wife Nancy and me.

Robert and Elinor Gregory, David Gregory, Linda Stock, Monica Foran, Michael Petrucelli and Jim Richetelli shared memories and photos.

The Walnut Beach–Myrtle Beach Historical Association, which published the wonderful memoir *Sand in Our Shoes* several years ago, shared some of the photos collected but not used in that book. Jeanette Acton of the association

also provided me access to the postcard collection of the late Henry "Buster" Walsh, which was left to the association and is available for anyone to view through the generosity of the association, Walsh's sisters Doris Walsh Williams and Arlene Walsh Freeman and the Milford Junior Women's Club.

Laura Katz Smith and her staff at the Thomas J. Dodd Research Center at the University of Connecticut in Storrs were generous with their time and helpful in their suggestions. William Caughlin, corporate archivist of AT&T Inc.; Michael Schneider, archivist for the Shoreline Trolley Museum/Branford Electric Railway Association; and the staffs of the Connecticut State Library, the Fort McMurray (Alberta) Historical Association and the Beineke Rare Book and Manuscript Library at Yale University provided images.

I'd also like to thank Julie Kinsella, the external affairs coordinator for the Academy of Our Lady of Mercy–Lauralton Hall; Lee Sterling, marketing executive for the Westfield Connecticut Post Mall; and William McDonald, head of the Peter Pond Society, for their help. Tom Baden, editor of the *Connecticut Post*, made the newspaper's photo archives available.

My friend, retired *New Haven Register* reporter Donald Dallas, performed the first "light edit" on the manuscript.

Tom Beirne and I have had many conversations about the Revolutionary War era in Milford, and he has come up with a great way to get people excited about history—by dressing up in period costumes and playing soldier on the Green. It's been a lot of fun, and the Redcoats have had even worse luck here in the 2000s than they did in the 1770s.

Finally, but most importantly, I want to thank my wife and partner, Nancy Hine Juliano, a descendant of Governor Jonathan Trumbull, who took the contemporary photos for this book and provided love, support and strong coffee.

# Chapter 1

# SETTLERS, NATIVES, MINISTERS AND PIRATES

Forget Manhattan. Milford—including what is now present-day Orange and part of Woodbridge—was the real bargain. Purchased for six coats, twelve iron axes, ten blankets, twelve hatchets, twelve hoes, two dozen knives, six mirrors and a kettle, it was, for lack of a better word, a steal.

That's probably what the Reverend Peter Prudden thought as he laboriously worked on the treaty conveying the land. There was even a "turf and twig" ceremony, a vestige of British real estate law that the natives probably found amusing. It involved handing a hunk of dirt—the land being conveyed—to the party selling it, who stuck a twig in it and handed it back to the buyer.

It symbolized that ownership of the land and everything on it was being turned over. While many Native Americans, being used to hunting and fishing in one spot for a while and then moving on, probably didn't understand the European concept of land ownership, it appears that Paugussett sachem Ansantawae did.

There were ultimately nine treaties, extending Milford east to New Haven and north to what is now Waterbury. Each document carried the mark of the sachem; Ansantawae's was an arrow inside a circle. The heavy parchments also had a notation stating that the Indians understood what they were signing. It was written by one of the settlers.

With each transfer of land, the local Paugussetts withdrew farther into the wooded countryside, though they retained fishing rights at Gulf Pond and off of Charles Island. At one point, the natives had so little land left that they asked the colonists for some back and were given about fifty acres for a "reservation" at Turkey Hill in what is now Orange and Derby.

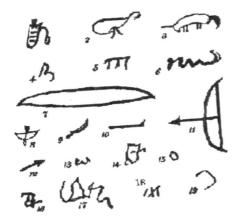

A collection of the "signatures" of Connecticut tribal sachems, or chiefs, that were used on treaties with European settlers. Ansantawae's mark is No. 8. *Used with permission of the Connecticut State Library.*

The natives did seem to understand that they were conveying the land itself, not just access to it, and those treaties were the basis of Milford's exclusion from Indian land claims that caused so much consternation in Fairfield County in the mid-1990s.

The two groups had first interacted in 1637, when Thomas Tibbals came through the area with the militia, chasing the warlike Pequot Indians. The Paugussetts saw the settlers as allies in their ongoing battles with the aggressive Mohawks and other tribes.

## Two Versions of Justice

The Mohawks would send raiding parties sweeping down from central New York to take stored food, blankets and whatever else they could get hold of from the Paugussetts.

In 1648, the colonists discovered that the Mohawks were planning an attack against the Paugussett encampment on the Housatonic. They notified the natives, who were thus prepared and fended off the raiders. During that skirmish, the local Indians captured several Mohawk warriors and extracted their own brand of justice on one hapless raider.

The Paugussetts had tied a Mohawk warrior to a stake out in the salt marsh, leaving him to die. Either he would drown when the tide came in or else the mosquitoes and biting horseflies would finish him off; it didn't matter either way to the local Indians. But oral tradition says that a settler, Thomas Hine, rescued the Mohawk, leading to one of the oddest native-

settler encounters. The Mohawks felt indebted to Hine, and they would return every year to pay tribute to Hine and his family.

Some years later, in 1671, some boys in the settlement apparently thought they were playing a prank when they burned down the Paugussett fort. It may have been an accident, and the fort, near the present-day Baldwin Crossing condominiums, was not occupied. The Milford parents could have just shrugged and said something to the effect of "Kids today!" But they didn't.

The Paugussetts had the vandals hauled into the General Court in New Haven, where they were each fined ten pounds—a hefty amount in those days. The natives then rebuilt their fort. This incident may have been the first time that an Indian sought redress in an "English" court and won the case.

## How Friendly Were the Indians?

Just like the typical image of the first Thanksgiving, in which Squanto passes the succotash to Major William Bradford at Plymouth Plantation, Milford's "memory" of relations with the Paugussetts has undergone some revisions over the years.

We know that a man who called himself "the last Paugussett in Milford" played the cornet in an 1891 band concert here, and also that members of the current Golden Hill Paugussett tribe marched in the city's 350th anniversary parade in 1989.

Settlers respected the burial ground of 150 Paugussetts at Gulf Pond, leaving the area open and undeveloped down to the present day. A 1940 archaeological survey done by Yale University found that many of the remains were of children, buried in an orientation so that they faced the sun.

But while there were clear examples of cooperation, coordination and mutual assistance, for many years the settlers also surrounded themselves with a wooden stockade. What was that about?

Early accounts of Milford's founding describe the English bringing their guns to the meetinghouse and posting a sentry outside to protect them during church services. It is fair to assume that they weren't trying to protect themselves from long sermons. The settlers also banned the sale of guns to the natives and built a stockade of tree trunks to enclose a square mile of land. According to an 1834 history of Milford, the Paugussetts had become angry over the settlers' relentless trapping of beavers—and of their cutting down of so many trees.

The same historian wrote that the natives laughed at the settlers for penning themselves up like chickens in a coop. That didn't stop the Paugussetts from trying unsuccessfully to burn down the palisades in 1645. The blackened scar on the ground gave its name to Burnt Plains Road.

And according to local legend, the Paugussett sachem Ansantawae put a curse on Charles Island because he believed that English settlers had kidnapped his daughter. The curse was that nothing would grow on the island, and it is debatable whether it was effective. While attempts to grow tobacco there failed, some businesses flourished for a time on the island. The site is now a rookery for rare shore birds.

## THE REVEREND PETER PRUDDEN

In an era when there was no separation between church and state—in fact, to be able to vote a man had to belong to the Congregational Church—the town's minister was a very important person. All public meetings were held in the church, which functioned as a seat of government, including a court.

A reproduction of the list of "free planters," the male property owners eligible to vote in the new colony. *Courtesy of the City of Milford.*

The minister at that time had to be a political as well as a spiritual leader, and fortunately, the English settlers here had such a man in the Reverend Peter Prudden. He had led a group from Hertfordshire, where he was from, first to Massachusetts. Records of the city of Dedham indicate that land was set aside there for Prudden and fifteen followers in 1637, which they did not accept. A year later, they briefly joined the New Haven Colony, settling in the area of the Quinnipiac River.

But Prudden, described by a contemporary as "full of boiling zeal," drew others to him who had not come with him from England, and soon the group became quite large. After hearing from Captain Thomas Tibbals of the pleasant harbor just a few miles to the west, Prudden's group made plans to relocate here. Unwilling to be idle during the nearly two years it took

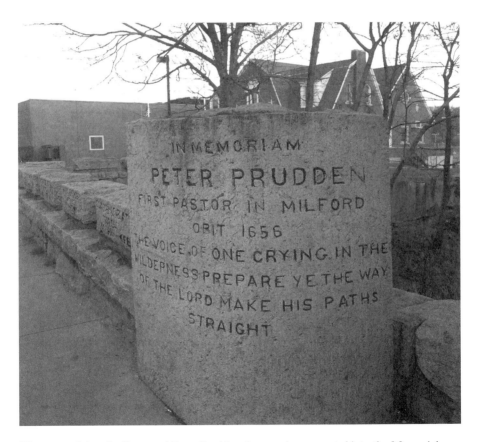

The memorial to the Reverend Peter Prudden that was incorporated into the Memorial Bridge. *Photo by Nancy H. Juliano.*

to organize the new community, Prudden preached in Wethersfield. The impression he made there was so strong and favorable that, according to a descendant, Henry J. Prudden, "he was followed to Milford from Wethersfield by many, that they might enjoy his pious and fervent meditations."

The First Church was formed in August 1639, barely six months after the settlement, called "Wepawaug" at that time, had been founded. Since the British Crown was thousands of miles away over open ocean and thus not able to assert any real control, the Bible served as the settlement's code of law. Prudden drew up a sort of constitution, which he called a covenant, for residents of the new settlement, which declared it to be a Christian community. Forty-four members were declared "free planters"—that is, eligible to vote.

A graduate of Cambridge, Prudden was voted one of the seven "Pillars" of the new community. There is no record of him ever taking a salary, and he allowed his garden to be used for the first burials in the settlement. That area is now adjacent to the Prospect Street side of the Milford Cemetery.

Years after Prudden's death, Cotton Mather, well known for his role in the Salem witch trials, said that the Milford minister was "an able and faithful servant of the church…when his death was felt by the colony as the fall of a pillar which made the whole fabric to shake."

Despite his vital service to the Milford colony and to the congregations he served, Prudden's grave is not marked. It is known that he died in Milford, but as tombstones were not yet being used, he perhaps was laid to rest behind his house, alongside those he had pastored so well.

## A Community Set Apart

One would assume that Milford began as part of the larger, adjoining New Haven Colony and then broke away, but that's not how it happened. When Wepawaug was formed it was as a separate community, but within a few years the advantages of consolidation had become obvious.

Although Indian attacks were rare, given the generally good relations between the settlers and the natives, disputes between the Dutch and the English led to skirmishes elsewhere in Connecticut, sometimes with Indian allies fighting on either side. An alliance between the Plymouth, Massachusetts Bay, Connecticut (Hartford) and New Haven Colonies was proposed in 1643 for mutual defense.

The so-called New England Confederation allowed members to keep their own governments and identities but pledged them to assist one another in times of crisis. Leaders of the Milford colony, rather than be left outside of this arrangement and thus completely on their own, petitioned to consolidate with the New Haven settlement.

But the brief period of complete independence had raised some complications. Six men who were not members of the church had been granted full civil rights, including the right to vote and to serve in government, by the Milford colony. That was simply a deal-breaker to the rest of the confederation, strict Puritans that they were. New Haven leaders insisted that the six be disenfranchised before Milford could be admitted, and local leaders refused.

The compromise finally reached allowed the men to retain their rights within Milford and to vote for deputies of the General Court in New Haven, but not for the higher office of magistrate or in any matter that affected the "combination," or the New England colonies as a whole. William Fowler and Edmund Tapp were elected as the Milford deputies to the General Court, and the colonies were consolidated.

# CAPTAIN WILLIAM KIDD

In the late 1990s, a group of professional salvagers and treasure hunters applied to the state Department of Environmental Protection for permission to excavate Charles Island and to search the water immediately around it for Captain Kidd's treasure. This led, no doubt, to some chuckles among the bureaucrats in Hartford, and finally to the denial of permission. State officials cited the presence of rare shore birds that needed protection as their main reason for saying no.

Hobbyists with metal detectors and the idly curious still try to locate the buried treasure of the ill-fated privateer. Kidd was known to have been in Milford more than once and would have sailed directly past Charles Island on his way from New York City to Boston to face charges in 1699.

He must have known that something was up, because on that voyage he did stop and bury treasure on Gardiners Island at the tip of Long Island Sound. He hoped to use that as a bribe—or an inducement—to get officials in Boston to drop piracy charges against him.

That treasure, including diamonds, gold bars and gold dust, was dug up and recovered as evidence. Kidd's letters of marque were challenged. He

was shipped back to England, where he was tried and hanged for piracy in 1701.

Towns up and down the East Coast have claimed that Kidd buried booty there, and—although his biographers tend to discount it—there is at least some reason to think that Captain Kidd did make an unscheduled stop here.

A letter found in one of Milford's oldest houses more than one hundred years ago recounts a visit in which he boldly sauntered along the main street, kissing a young lady and causing all sorts of consternation. The writer, Patience Tuttle, describes that incident and offers this intriguing tidbit: "I overheard Jacobeth say that Kidd was going on a long cruise and that he had left some things with him."

But the letter may in fact have been a hoax. Genealogists can't find a Patience Tuttle in Milford in Kidd's day, and the first time that the letter is mentioned is in an 1889 magazine article. The story is repeated in the 1939 WPA history of Milford.

Except for the Gardiner's Island stash, which Kidd himself disclosed to his jailers, no treasure has ever been found. The severe hurricane of 1938 altered the coast of Long Island Sound, obliterating whatever physical clues might have remained. And in all of those years since Kidd's hanging, Charles Island was a pretty bustling place. There were at various times on the small island a summer hotel, a factory to make fertilizer from the plentiful menhaden and a religious retreat.

Although local merchants sponsor a popular "Captain Kidd Day" in early June, it is likely that the only "treasure" on the island now is the wildlife…and the guano.

## PRIVATEER GEORGE COGGESHALL

Milford native George Coggeshall, on the other hand, carried a letter of marque—official permission from the U.S. government to prey on the shipping of other countries. His capture of several British and French ships is well documented, and despite the legal gray area he operated in, Coggeshall received a hero's welcome when he returned to Milford.

Among his eighty voyages between 1799 and 1844 was his trip on the Milford-built, two-hundred-ton schooner *David Porter* in 1814. The captain seized a French ship, sailed that vessel into the English Channel and captured three British ships. Coggeshall sent two back to America with the loot and sailed on in the third.

But eighty miles off the coast of Lisbon, his ship lost its mast. When he went into Lisbon Harbor for repairs, Coggeshall was captured by the British and sent to prison on Gibraltar. Soon, though, the Milford sea captain had escaped and made his way back across the ocean to home.

According to a descendant, Henry Coggeshall Howells IV, the privateer asked his guards if he could go into town for a glass of wine. Somehow, he slipped away and asked the captain of a Norwegian ship for safe passage. That captain coordinated with a group of smugglers to take Coggeshall to Algeciras, Spain. From there, the Milford man made his way to Cadiz. Two months later, he sailed to Lisbon and returned to the United States aboard a Portuguese brig in May 1815.

Another Milford resident, Adam Pond, captained the coastal schooner *Theresa* and built a larger boat in Milford, the *Sine Quo Non*, which he used as a privateer—basically a licensed pirate—in raids against British ships. Adam Pond ran the blockades of Long Island Sound in the early 1800s and was the first to inform Milford residents that Napoleon had escaped exile in Elba.

Chapter 2

# MILFORD GOES TO WAR

## STEPHEN STOW AND THE SMALLPOX VICTIMS

*Greater love hath no man than this, that a man lay down his*
*life for his friends.*

—*John 15:13*

Consider the selflessness of Stephen Stow. When a group of sick and bedraggled prisoners of war was practically dumped on his doorstep from a British prison ship in 1777, he made out his will, kissed his wife goodbye and cared for forty-six men gravely ill with smallpox until they all died.

There were more than two hundred Continental army soldiers and volunteers sick with smallpox and abandoned by the British here on New Year's Day that year. Most eventually made it home, but the forty-six who did not were cared for in a "pest house" near the site of the present City Hall. Stow had no medical training; he was a businessman. None of his patients was from Milford—the closest was from Stratford, and one hapless volunteer had come from Spain to fight for American independence.

Stow is still remembered and honored today for seeing a need and filling it, for making the big gesture in a quiet, almost off-handed way. The monument in Milford Cemetery that is dedicated to Stow and the soldiers he took care of is believed to mark the mass grave of the men, though there is some dispute over the grave's exact location. Remarks at the monument's 1852 dedication indicate that the bodies were placed end to end in a long trench. Also, the smallpox victims succumbed at different times through the winter and early spring of 1777, making one burial site unlikely.

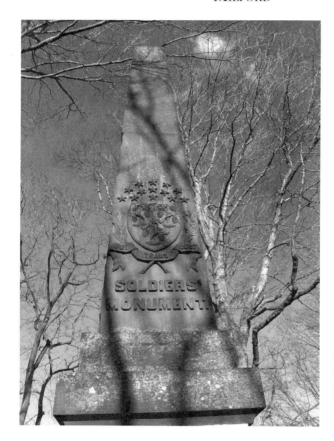

The Soldiers Monument in Milford Cemetery, dedicated to Stephen Stow and the smallpox victims he cared for. *Photo by Nancy H. Juliano.*

Historians believe that the graves may be under the railroad tracks, built along the edge of the cemetery in the late nineteenth century. But while a team of archaeologists and historians works to pin down the exact position of the burial site, Stow's courageous act continues to inspire people. The incident may also have led indirectly to the Geneva Convention and other modern codes of military conduct regarding prisoners.

Conditions on the fetid, dank British prison ships—most of them anchored at what later became the Brooklyn Navy Yard—were so bad that it resulted in the first treaty on prisoners between nations. In 1785, only two years after the end of the Revolutionary War, the United States and Prussia negotiated a pact that outlawed dungeons, irons and prison ships and required humane treatment of captives. It is believed to be the first treaty of its kind; Prussian soldiers who served the British as mercenaries would have seen firsthand the methods that had been used.

# Milford Goes to War

It was the British custom to abandon sick POWs up and down the Connecticut coast. As many as one thousand men would be crammed into the steaming hulk of a prison ship, and up to twenty would share a single cell in the New York jail. The men dropped off in Milford were likely captured during the Battle of New York, in which the Americans surrendered the then-capital city.

Some who walked from Milford to their homes died along the way, and at least one made it back to his parents' home in "Chatham," now Portland, Connecticut. Disease, especially smallpox, was rampant among British POWs. Smallpox was a common but deadly illness in the eighteenth century, though people had learned that surviving it provided immunization.

John Downs, the Revolutionary War veteran and a weaver here for forty years, wrote in his diary about suffering smallpox and dosing himself with mercury to cure it. Downs later went to New Haven to care for victims of a smallpox outbreak because of his immunity.

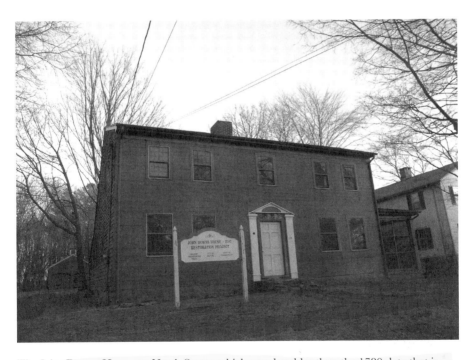

The John Downs House on North Street, which may be older than the 1780 date that is commonly given. The city bought the property to protect it from development. Downs, a weaver and war hero, kept a daily diary for forty years. *Photo by Nancy H. Juliano.*

# REVOLUTIONARY FERVOR

Milford had been a hotbed of Revolutionary fervor since the first imposition of King George III's "Intolerable Acts"—so much so that the few Tory families in the area had to pack up and move on to more welcoming communities. A well-organized militia and a coordinated network of sentries probably kept Milford from the devastation that the British wrought in New Haven, Fairfield and other coastal communities.

One of the key lookouts was Hog Rock in what is now Devon; it was renamed Liberty Rock by Patriots at the outbreak of hostilities in 1775. The large granite boulder, big enough for several men to crouch behind, once commanded a clear view of Long Island Sound from its inland perch.

Development has blocked the view, and historians agree that the rock has been moved at least once in the name of progress. But Liberty Rock is now the centerpiece of a small park on Bridgeport Avenue, an oasis in an asphalt sea of motels and stores. Liberty Rock still commands the highest point in

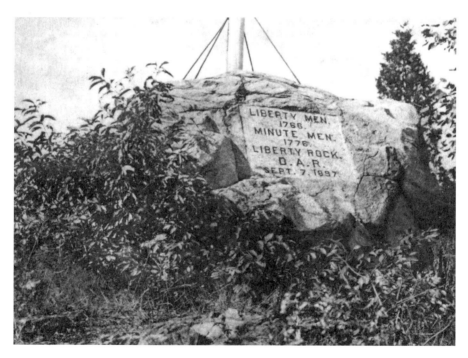

An early twentieth-century view of the famed Liberty Rock, a lookout for Patriots scanning the shore for British warships. *From the Henry "Buster" Walsh postcard collection.*

the area, even if the old coach road that used to pass in front of it has also been relocated and renamed.

The old boulder still has its earliest graffito; "Liberty 1766" is carved into the back of it. That would have been the time that the Stamp Act took effect in the colonies; it had people here pretty worked up.

Milford residents played an active role in the war too. Voters at a November 1774 town meeting approved a collection "for the relief and support of such poor inhabitants of the Town of Boston as are immediate sufferers of the Boston Port Bill."

Seventy-three citizen soldiers from Milford, under the command of Captain Peter Pierett, marched to Boston to defend that city after the Battle of Lexington began the Revolutionary War. The cost to Milford of organizing and equipping this light infantry unit was 138 pounds and 11 shillings. Later, Captain Jehiel Bryan and Captain Orlando Beach commanded Milford's shore defenses so effectively that the British decided to capture them. According to a contemporary account, a British officer was rowed ashore at dusk by two of his men and raided Bryan's house with his sword drawn. It didn't go well for the invader. "Upon meeting the doughty Bryan in the hall he was so thoroughly trounced and shaken that he fled with his men, leaving his sword behind," is the report of the incident in town records.

Fort Trumbull was built in 1776 at a cost of ninety-five British pounds and outfitted with six large artillery pieces dragged here from New Haven. Soldiers manning the fort were to be paid forty shillings per month. Whether they actually collected that pay isn't known, but a local law passed later in 1776 strictly forbid "the wasting of ammunition."

When a British raiding party from the HMS *Swan* came ashore near Point Beach in the summer of 1777, they were not unexpected—and not very successful. Townspeople, aware of similar raids up and down the coast, had taken the precaution of hiding many provisions and foodstuffs from easy view. Foraging parties looked for anything they could carry off easily and some things, such as cattle, that were less portable.

Most of the town's dairy and beef cattle had been herded into a deep gully at the edge of a salt marsh today known as Calf Pen Meadow. The forty hungry British seamen who rowed ashore from the anchored *Swan* found no cattle at Miles Merwin's farm, so they set about breaking glass and wrecking the interior of his home.

If that was meant to terrorize the lady of the house, known to history as Mistress Abigail Merwin, it had the opposite effect. She ran from the kitchen with a baby on her hip, stopping to grab a copper pot and a wooden spoon.

She hitched her horse to its wagon, climbed in and sounded a general alarm by beating on the pot with the spoon.

By the time she had reached the center of town, a distance of about three miles, the militia had gathered and was preparing to repulse the raiders. The swift notice allowed the local men to chase off the British, who scrambled into their boats and rowed back to the *Swan*. Contemporary accounts say that their total haul included a hog and a few cheeses.

Among those drawn to enlist in the Connecticut militia was fifteen-year-old Joseph Plumb Martin. He signed up at the Clark Tavern for a six-month term, over the objections of his grandfather and guardian. After seeing action in the Battle of Brooklyn—during which the rebels had the British army in full retreat before their ultimate defeat—the boy decided not to reenlist.

Milford in winter can be boring—they knew that even back then—so Martin singed up for the Continental army in the spring of 1777 and served under General George Washington at several key battles. After the war, he moved to Maine and lived in obscurity until, in 1830, he was called upon to establish his eligibility for a military pension. Then Martin produced a memoir, *A Narrative of Some of the Adventures, Danger and Suffering of a Revolutionary Soldier, Interspersed with Anecdotes of Incidents that Occurred Within His Own Observation.* Considered the best firsthand account of the daily life of a Continental army soldier, the book detailed the frustrations and the sufferings of the war.

Martin recalled his regiment having a large-bore cannon at one key battle but no ammunition for it. He also described a harsh winter that must have made him nostalgic for Milford: "I endured hardships sufficient to kill half a dozen horses. Let the reader only consider for a moment and he will still be satisfied if not sickened. In the cold month of November, without provisions, without clothing, not a scrap of either shoes or stockings to my feet or legs, and in this condition to endure a siege in such a place as that was appalling in the highest degree."

The book has been reissued in recent years under the more memorable title of *Private Yankee Doodle.*

A local man contributed in some small part to one of the most famous incidents in the war. Captain Charles Pond, commanding the sloop *Schuyler*, sailed spy Nathan Hale across Long Island Sound to Huntington in 1776. Hale was captured there and hanged as a spy, famously regretting that he had only one life to give for his country.

## The "Home Guard"

Who were the Milford Grenadiers? A fierce, elite fighting force that won the respect of foreign military leaders, or a bunch of local fops and dandies?

The historical record suggests that they were a little of both. The Grenadiers, organized in 1783, liked to dress in fancy but impractical uniforms. The seventy men who made up the unit at full strength were tall for their day—members had to be at least five feet, nine inches in height. But they must have seemed even taller than that in their high, plumed red caps. The dress uniform was described in contemporary accounts as "a scarlet coat with buff facings, heavily decorated with gold braid, drab knee breeches with buckles and high, tasseled boots." And, of course, that eighteen-inch-high hat, which was topped with an ostrich plume.

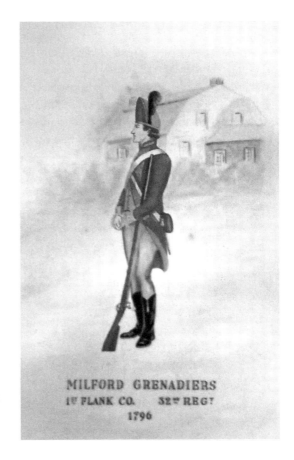

A Milford Grenadier, resplendent in full uniform. *Courtesy of the Milford Historical Society; photo by Nancy H. Juliano.*

As a local militia, or home guard, it is doubtful that the Grenadiers ever saw any military action or even left Milford. Legend has it that during the War of 1812, the sight of the unit, resplendent in their ornate outfits, was enough to scare off a British ship that had moored off Fort Trumbull Beach.

Their reputation soared when the Duke of Wellington, who would defeat Napoleon at Waterloo, supposedly told a visiting Milford official that year that he was more concerned about the prospect of facing the Grenadiers in battle than he was about the French emperor. The remark, almost certainly tongue-in-cheek, was made in Lisbon during a meeting between Captain Charles Pond and Wellington. Pond, the sea captain who had ferried Nathan Hale to Long Island during the Revolution, complained to the commander of the British forces that three of his crew had been seized by the British during his Atlantic crossing: "Our interview was brief. He looked disturbed, and as we parted he took my hand and said, 'Captain Pond, we are now engaged in war with France, but I have no fears of the result. I shall vanquish Bonaparte. But heaven save us from a war with the United States so long as the Milford Grenadiers retain their reputed efficiency, discipline and bravery,'" Wellington was quoted by Pond.

Who knows? It might have happened. Historians don't dispute Pond's version of the meeting, which he recounted to his fellow Grenadiers at a local tavern upon his return from Europe. No one recorded how many rounds of rum or grog had been consumed that night.

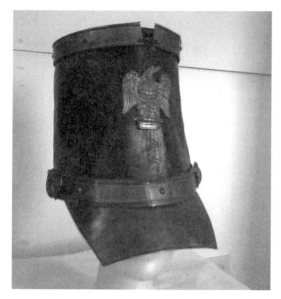

A Milford Grenadier helmet, worn by a member of the Platt family and donated by Richard N. Platt to the Milford Historical Society. *Photo by Nancy H. Juliano.*

Although the Grenadiers' role was largely ceremonial, membership was considered an honor, and had the need ever arisen, the men were duty-bound to protect the citizenry of Milford.

It is likely that the British commander would not even have heard of the local militia had not Pond introduced himself as a member.

## CAPTAIN HENRY G. MARSHALL AND THE CIVIL WAR

The movie *Glory* detailed the heroism and sacrifice of a unit of black Civil War soldiers commanded by a white officer. The Massachusetts regiment commanded by Colonel Robert Gould Shaw that was the focus of the 1989 film had a similarity to one commanded by a Milford man.

Captain Henry Grimes Marshall led the Twenty-ninth Connecticut Colored Infantry, the state's only African American unit in the war. The captain, unlike Shaw in *Glory*, survived the war and later became an ordained Congregational minister.

Marshall was born here in 1839 and graduated from Yale in 1860. After two years of teaching in New Jersey, he returned home to enlist in the Fifteenth Connecticut Infantry of the Union army in 1862. He wrote home to his sisters from Maryland that his rank of sergeant would likely keep him out of the thick of the battle. "If I do get in my position is behind the line and I don't have to fire but [to] look out that the rest do," the Milford officer wrote. His unit did see action at Fredericksburg, Virginia, and soon after Marshall began to contemplate taking a commission with a regiment of African Americans.

It would be more dangerous, he wrote in a letter that is now in the Schoff Civil War Collections at the University of Michigan. "I think nothing of the extra danger for in war I don't see much difference. A man in the least dangerous spot may be killed," Marshall wrote.

The unit he commanded marched proudly through the streets of New Haven, but Marshall found that the race and status of his troops meant that they were often the last to receive equipment and supplies. There is documentation that Marshall vigorously opposed that and fought for the fair treatment of his men.

Marshall's motives for wanting to command a unit of black soldiers seem more complex than just simple idealism. Although he was a staunch supporter of the Union cause, some of the captain's letters show a mounting regret about the lives being lost. Turning reflective near the end of the war, Marshall wrote home that the country had been "purified" by it. "God has come nearer

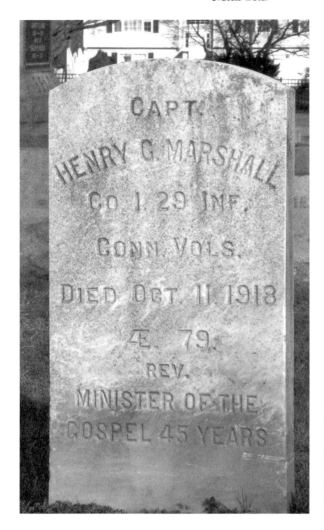

The Milford Cemetery gravestone of Henry G. Marshall, who commanded a Connecticut regiment of black soldiers during the Civil War and later became a prominent Congregational minister. *Photo by Nancy H. Juliano.*

to many families, by taking some member who had gone off to fight. There are many and great evils about this war, but somehow to myself seem to see great good coming there from."

The Twenty-ninth Connecticut participated in the Port Royal Island battle off the South Carolina coast, the same one that Shaw and his men took fierce casualties in. The battle was fought mostly by black Union army troops.

After the war, Marshall became a minister and served a Congregational church in Cromwell for many years. He preached at one of the services here to mark the 250th anniversary of the First Church of Christ, Prudden's church, on August 21, 1889. He is buried in Milford Cemetery.

## GENERAL G. WILLIAM BAIRD AND THE WAR ON THE PLAINS

The city's only U.S. Medal of Honor winner fought in the Civil War too, but it was for his later service in the Indian wars on the Great Plains that he earned his medal.

George William Baird was born in Milford in 1839 and is buried here, but in between he led a busy life: graduating from Hopkins Grammar School and Yale University, writing a memoir of his Indian fighting days and later serving as the U.S. Army's deputy paymaster. During his long military career, he rose from the rank of private to brigadier general.

The Medal of Honor was awarded for his heroics against the Nez Perce Indians and their leader, Chief Joseph. The U.S. Army had hunted the Nez Perce across Montana in the summer of 1877, and on September 30 the two sides squared off for a final time at Bear Paw Mountain. Chief Joseph had led his tribe out of Oregon, across much of Idaho and Wyoming and into Montana, decisively winning an encounter with the army at Canyon Creek. Army scouts had determined that the Nez Perce were headed to Canada, and Baird's unit was one of several under General Nelson A. Miles racing to cut Chief Joseph off.

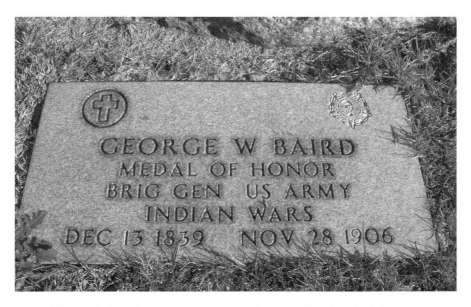

General George W. Baird's gravestone in Milford Cemetery. Baird received the Congressional Medal of Honor for bravery in the battle against the Nez Perce Indians. *Photo by Nancy H. Juliano.*

Baird at the time was a first lieutenant with the army's Fifth Infantry division. His citation credits his "distinguished gallantry," and he was twice wounded himself as he retrieved injured soldiers from the battlefield.

However heroically the Milford man fought that day, Chief Joseph also made a name for himself. Even though history is written by the winners, the Nez Perce chief was honored for his bravery, leadership and military skill. A national heritage site in Montana marks the battlefield with his name, not Baird's or Miles's. Perhaps it is due to the words Chief Joseph used in his famous surrender: "I will fight no more forever."

Chapter 3

# POLITICIANS, EXPLORERS AND INVENTORS

## THE GOVERNORS: ROBERT TREAT, JONATHAN LAW AND C.H. POND

A Milford man, James Amann, was a candidate for the Democratic nomination to run for governor in 2010. It was a crowded field, and the local man faced an uphill campaign, before bowing out.

Amann—the former House Speaker whose accomplishments for his hometown are already numerous—wouldn't have been the first local person in the state's top job. In fact, he would have been the fourth.

Robert Treat was a land surveyor who served as a colonial-era governor of Connecticut for fifteen years, from 1683 to 1698, one of the longest tenures in office. But his time as governor was merely the cap to a long political career that saw him hold office in two states.

It isn't likely that any Connecticut governor will have to face the issue that Treat did: whether the colony had a right to exist at all. Several times during his term in office, attempts were made to merge the area that is now the state of Connecticut with New York. He also presided over the famous "Charter Oak" incident, in which he was ordered to turn over the colony's charter.

The official account is that Edmund Andros, the governor of New York, New Jersey and Massachusetts at various times and the agent of King James, had come to Hartford personally at the request of the king to revoke Connecticut's charter. The precious document was on the table between the two men as Treat made his impassioned—and hours-long—appeal. Candles were lit as darkness descended, but all of a sudden a door opened, the wind

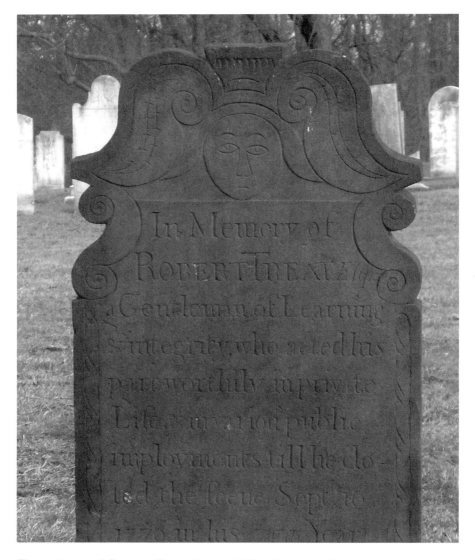

The tombstone of Governor Robert Treat in Milford Cemetery. Treat was present at the "Charter Oak Incident," in which a representative of the British king attempted to revoke the Connecticut colony's charter. *Photo by Nancy H. Juliano.*

blew out the candles and the charter was gone. It had been hidden in a tree outside, but Andros never knew what happened.

The governor was also reputedly a friend of the "regicide" judges, Whalley and Goffe, who successfully eluded capture some years earlier in New Haven

after the British monarchy was restored. While the judges' hideout in a cave on West Rock in New Haven is now well known, their three years in seclusion here are not. They sheltered with Micah Tompkins and his family in a home on West River Street, beginning in August 1661. Their presence here was a well-kept secret, but Treat, at the time a court magistrate, almost certainly knew and approved.

Treat had been the Milford colony's first land surveyor in 1639 and laid out the first house lots here, in the area immediately surrounding the harbor. One might say then that he left his stamp on the community in ways that succeeding elected officials could not. To drive down Prospect Street and turn onto New Haven Avenue is to follow the layout originally drawn by Treat in the first year of settlement.

He was also the tax collector in Wethersfield in 1647, a deputy of the New Haven Colony's General Court and then a court magistrate, the town clerk of Newark, New Jersey, in 1667–68 and a delegate to the New Jersey legislature before returning to Connecticut. Treat was the deputy governor (the position now known as lieutenant governor) both before and after his term as governor. He died in 1710.

Jonathan Law, for whom the high school in Devon is named, was a Milford native and a Harvard graduate who served first as chief justice of the Connecticut Superior Court from 1725 to 1741. It is fitting, given his name, that Law would spend so much of his career in the judiciary. He began as a justice of the peace in 1709 and was a judge of the New Haven Colony Court from 1710 to 1725.

He became governor in 1741, at the age of sixty-seven, and he died in office in 1750. During his tenure, Law sent Connecticut troops to Nova Scotia, fighting on the side of the British in the "War of Jenkins's Ear," known in America as King George's War.

Unlike his predecessors in office, Governor Charles Hobby Pond served during a relatively quiet period of Connecticut history. The scion of an early, important Milford family, Pond is to this date the only local resident to serve as governor after Connecticut became a U.S. state.

Pond attended Yale and studied law but never practiced it. Instead he took a series of ocean voyages, and when he returned to Connecticut in 1819 at the age of forty-two, he became a New Haven County sheriff. Later, Pond served as a judge and was elected lieutenant governor in 1850. He became governor a year later when the incumbent resigned to become U.S. minister to Russia but left office himself without running for a full term of his own.

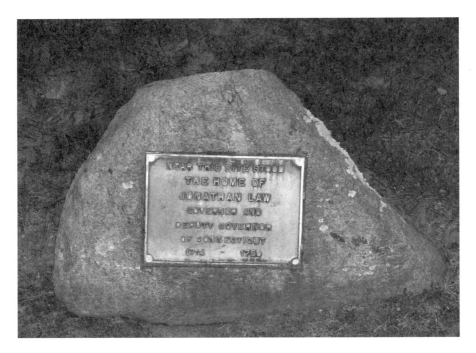

Marker on the site of Governor Jonathan Law's homestead in Milford. *Photo by Nancy H. Juliano.*

Upon his death in 1861, Pond was recalled by a friend as a "favorite of every circle, young and old, because of his intellect, wit and his 'generous heart.'"

## PETER POND AND THE FUR TRADE

Considered a key figure in Canadian history, Milford native Peter Pond may be better known in Fort McMurray, Alberta, than he is in his hometown.

A member of one of the city's founding families, Pond died here in 1807 after a thirty-five-year career of fur trapping, trading and mapping the upper reaches of the Great Lakes region in the United States and the northwest territories of Canada. Although historians are nearly certain that he is buried in or near the family plot in Milford Cemetery, his unmarked grave has yet to be found.

In a way, that is particularly fitting for this restless soul who defied his parents and left Milford at sixteen to join the British in the French and Indian

War, returning home only sporadically in the next fifty years. Pond would sometimes go a year at a time without seeing another English-speaking person. His trading partner, Alexander Mackenzie, described Pond at their first meeting:

> *Pond stalked into the hall, a pack of dogs at his heels. The gray-haired giant had not shaved in weeks, his buckskins were stained, and he was badly in need of a bath. But his natural dignity was overwhelming. He ate a large venison steak, a platter of bear-bacon, and a moose liver. He insisted his dogs be given fresh meat, too.*

But the reason why the Fort McMurray Heritage Park in Alberta has a cairn honoring Pond, and a nearby town has a Peter Pond Motel, is the local man's charting of the headwaters of what is now known as the Mackenzie River. Pond surmised, correctly, that this river eventually flowed into the Pacific Ocean. His maps underestimated the distance between where he was and the coastline. Mackenzie got most of the credit, and he is the one who

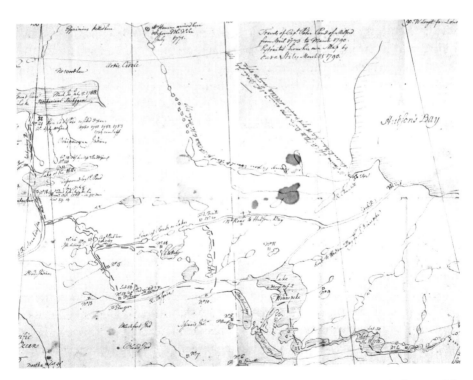

Map of the Athabasca region of upper Canada, drawn by Peter Pond in 1790. *Courtesy of the Beinecke Rare Book and Manuscript Library at Yale University.*

actually got to the Pacific from upper Canada, but some historians consider Pond and Mackenzie together the Canadian counterpart to Lewis and Clark.

When he left home in 1756, Pond spent four years in military campaigns against the French, and it is likely that he spoke some French as well as a few Algonquin Indian languages. In 1760, he left Montreal for a voyage to the West Indies and then spent three years back in Milford caring for younger family members while his father was off exploring.

He then spent six years as a fur trapper and trader in the area of what is now Detroit, Michigan, before heading off to the Lake Athabasca region of upper Canada. Reputedly a hotheaded and stubborn man, Pond was twice accused of murder but both times was acquitted.

In 1790, Pond sold his share of the Northwest Trading Co. and returned to Milford a wealthy man by the standards of the day. Yet when he died seventeen years later, he was reported to be nearly penniless.

When Mackenzie published his book *Voyages* in 1801, to much public acclaim, Pond also tried writing his memoirs. The book was never published and may never have been finished. Not having spent much time in school, Pond's spelling and grammar were atrocious, though his descriptions were vivid: "Being then Sixteen years of age I Gave my Parants to understand that I had a Strong Desire to be a Solge and that I was Detarmined to Inlist." A fragment of the memoir, taking Pond's life through 1775, is in the Beinecke Rare Book and Manuscript Library at Yale.

What makes Pond's life resonate with people today is that many of us share the same wanderlust and spirit of adventure that he had, and also his love of home. Pond saw land white people had never seen before and then came back to Milford.

# GEORGE COY

Inventions by themselves offer the potential of a technological breakthrough, but they almost always need a second innovation to make them commercially viable.

Take, for example, the telephone. Alexander Graham Bell held many of the key patents for the device, but it was a Milford man, George Coy, who came up with the switchboard. Coy's advancement, built of carriage bolts, teapot lids and wire, is what made telephones in private homes practical. Before the switchboard, each pair of phones, however far apart, had to be connected by its own wire.

Coy was fascinated when he heard Bell lecture on the potential of the telephone and bought the "agency," or franchise, for much of southern Connecticut from the Bell Telephone Co. in September 1877.

Already an experienced telegraph operator, Coy developed the "exchange," or central office system. He had all of his subscribers' telephones routed to a New Haven station where operators—young boys at first—would patch the wires connecting two telephones together, allowing the parties to speak to one another.

From there it was a short leap to the first directory, a sheet listing the fifty subscribers of the New Haven District Telephone Co., including Coy, whose home had the first telephone in Milford. The February 21, 1878 list included several businesses, doctors' offices, factories, boarding stables and livery services, along with the New Haven Police Department, the local U.S. Post Office and the *New Haven Register* newspaper.

What is startling is that there were no numbers at all, since we now have ten-digit calling in Connecticut. But since operators were needed to patch the lines together—and calls could only be completed on weekdays when the Chapel Street office was open—subscribers were identified by name.

By the time the 1882 directory was published, there were twenty-two telephones in Milford, including five in private residences. Coy had already gone on to his next innovation—the trunk line.

Now owning the rights to telephone service in Hartford and Springfield as well as New Haven, the local entrepreneur collected $40,000 from investors to connect his far-flung exchanges, allowing the first toll calls. Soon after, Coy's company became known as the Southern New England Telephone Co., a name it kept for the next one hundred years.

The advances came fast and furious after that, though Coy, who retired in 1898 and died in 1915, wasn't around to see them. Milford got its own exchange in 1896, and by 1947 it was no longer a toll call between here and New Haven.

But Milford officials, despite the town's connection to telephone history, remained profoundly skeptical of the device. Three times in the 1950s, voters at the town meeting rejected a proposal to replace fire alarm boxes with telephones.

Coy in his day had run into skeptics too. The local inventor wrote in a 1910 memoir, "I could get no advice that would help me in the least, from any of the Bell people. In fact, they rather discouraged me, saying it [the switchboard] would be too complicated."

# LIST OF SUBSCRIBERS.

## New Haven District Telephone Company.

### OFFICE 219 CHAPEL STREET.

### February 21, 1878.

**Residences.**

Rev. JOHN E. TODD.
J. B. CARRINGTON.
H. B. BIGELOW.
C. W. SCRANTON.
GEORGE W. COY.
G. L. FERRIS.
H. P. FROST.
M. F. TYLER.
I. H. BROMLEY.
GEO. E. THOMPSON.
WALTER LEWIS.

**Physicians.**

DR. E. L. R. THOMPSON.
DR. A. E. WINCHELL.
DR. C. S. THOMSON, Fair Haven.

**Dentists.**

DR. E. S. GAYLORD.
DR. R. F. BURWELL.

**Miscellaneous.**

REGISTER PUBLISHING CO.
POLICE OFFICE.
POST OFFICE.
MERCANTILE CLUB.
QUINNIPIAC CLUB.
F. V. McDONALD, Yale News.
SMEDLEY BROS. & CO.
M. F. TYLER, Law Chambers.

**Stores, Factories, &c.**

O. A. DORMAN.
STONE & CHIDSEY.
NEW HAVEN FLOUR CO. State St.
    "        "        "    " Cong. ave.
    "        "        "    " Grand St.
    "        "        "    Fair Haven.
ENGLISH & MERSICK.
NEW HAVEN FOLDING CHAIR CO.
H. HOOKER & CO.
W. A. ENSIGN & SON.
H. B. BIGELOW & CO.
C. COWLES & CO.
C. S. MERSICK & CO.
SPENCER & MATTHEWS.
PAUL ROESSLER.
E. S. WHEELER & CO.
ROLLING MILL CO.
APOTHECARIES HALL.
E. A. GESSNER.
AMERICAN TEA CO.

**Meat & Fish Markets.**

W. H. HITCHINGS, City Market.
GEO. E. LUM,        "        "
A. FOOTE & CO.
STRONG, HART & CO.

**Hack and Boarding Stables.**

CRUTTENDEN & CARTER.
BARKER & RANSOM.

Office open from 6 A. M. to 2 A. M.
After March 1st, this Office will be open all night.

The first telephone directory, made possible by George Coy's invention of the switchboard. *Courtesy of the AT&T Archives and History Center.*

# FRANK SPRAGUE

The next time you ride in an elevator or catch a train, think of Milford native Frank J. Sprague. Sprague, as much as anyone else in the nineteenth century, helped to develop the modern city, with elevators that made skyscrapers feasible and electric railways for commuters. Sprague does get due credit from his peers—electrical engineers and transportation designers—but he is largely unknown to the general public, even in his hometown.

The Shoreline Trolley Museum in East Haven has a permanent exhibit dedicated to Sprague, who is credited with developing key components of the electrically powered trains. The exhibit is housed in the museum's Sprague Building, opened in 1959 and containing one of the inventor's unique motors.

The Milford native began the first commercially successful trolley line in 1888 in Richmond, Virginia, using his traction motors and power pole that drew electricity from overhead lines. Within a year, electric trolleys had replaced horse-drawn ones in most U.S. cities.

Thomas A. Edison, who manufactured many of Sprague's motors, bought out the local man in 1890. According to an October 13, 1916 *New York Times* article on Sprague, the inventor was born here in 1857 and won appointment to the U.S. Naval Academy in Annapolis, Maryland, in 1874. He graduated seventh in his class, and during his military service, Sprague developed the first electric communication system on a U.S. Navy ship. After his work with trolleys, Sprague began to apply his technology to elevators, developing safer, faster ones that could carry more passengers. That in turn led to the feasibility of taller buildings. Sprague and his partner, Charles Pratt, sold that company in 1895 to the Otis Elevator Co., a forerunner of Connecticut-based United Technologies.

After Sprague's death in 1934, his widow gave many of his documents to the New York Public Library and funded the building in his honor at the Shoreline Trolley Museum. The Branford Electric Railway Association, the nonprofit owners of the East Haven museum, welcomed two of Sprague's grandsons at the opening of the permanent exhibit in 1999.

But even if he is underappreciated, Sprague's contribution to his hometown continues. Whenever a Metro-North Railroad train glides by or pulls into the downtown station, it uses a pole and a "shoe," both descendants of Sprague's original designs, to draw electricity from the overhead catenary system.

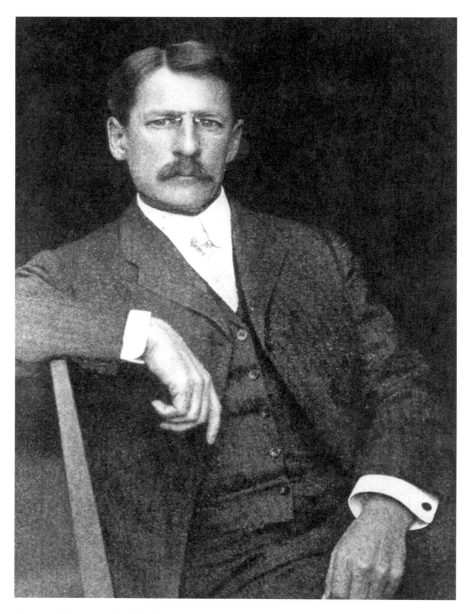

Portrait of inventor Frank J. Sprague. *Courtesy of the Shoreline Trolley Museum/Branford Electric Railway Association.*

# Simon Lake

Simon Lake, who experienced cycles of boom and bust as a businessman, always seemed to keep his emotions on an even keel. Fitting, because that is one of Lake's key advancements in submarine technology—and the origin of the expression. Before him, subs could go up or down, left or right, but not in two directions at once. His keel allowed the vessel to submerge while it was moving forward.

A man ahead of his time, Lake was a better engineer than a businessman. Some of his ideas, including the periscope, conning tower and escape hatch, were derided as impractical. In all, Lake held more than two hundred U.S. patents, including those for the key developments in submarine technology.

But the U.S. Navy rejected his plans, and several congressmen on a trial run in the Chesapeake Bay were so frightened that they demanded to be returned to port immediately. Most of them had gotten claustrophobic and wanted to surface, calling Lake's submarine a death trap.

When the navy licensed a competitor's prototype—a "plunger" that could either descend or move forward but not both at once—the local inventor offered his technologies to the Russian and German navies shortly before the outbreak of World War I. That led to twin horrors for Lake. German U-boats based on his designs were proving far superior to American subs, and the Germans had ignored his patents and refused him royalties. The fast, highly maneuverable U-boats played an even bigger role in World War II, when they actually sank U.S. ships in the Atlantic.

Born in 1866, Simon Lake grew up in New Jersey, and inspired by Jules Verne's novel *Twenty Thousand Leagues Under the Sea*, he designed his first submersible, the *Argonaut*, submitting the plans to the U.S. Navy in 1892.

When he began operations in Milford in 1900, he built a workshop behind his Broad Street house and outfitted it with what must surely have been the town's first solar panels. Lake formed several corporations to finance his projects, selling stock and sometimes covering investors' losses out of his own pocket.

Not all of his vessels were seaworthy. The rusted hulk of one of his boats, lying on its side in the muck at the edge of the harbor, is still visible at low tide.

A prolific writer as well as an inventor, Lake churned out five autobiographies and one of the earliest military textbooks on undersea warfare, *The Submarine in War and Peace*, in 1918.

Milford residents are far more familiar with Lake than they are with Sprague or Coy. Not only is Simon Lake Elementary School in the Devon section carrying on his name, but his last creation, the 1933 *Explorer*, is on

permanent display at the Lisman Landing Marina. Meant as a salvager, the gunmetal gray craft has what looks like a milk crate on one end, used to scoop and sift the harbor sediment. It would have been tethered to a larger ship when it was in use.

After years in various museums, the *Explorer* was brought back to Milford in 1998 by a man almost as flamboyant as Lake himself. The late J. Lloyd Fleming, then an alderman, rode in the small vessel, waving from the open hatch, as it was towed on a flatbed truck to its final berth.

And in the end, even the U.S. Navy acknowledged the local inventor's accomplishments, christening a submarine tender ship the USS *Simon Lake* in 1964. It was decommissioned in 1999 after serving several deployments around the world. Lake's niece, Winifred Lake Oldroyd, great-grandson Jeff and sister-in-law Celeste Lake attended the formal decommissioning ceremony at the Norfolk Naval Shipyard. Vice Admiral Thomas Fargo, the deputy chief of operations for the U.S. Navy at the time, told the more than 1,300 people in attendance that without Lake's advancements, practical, modern submarines would not have been possible.

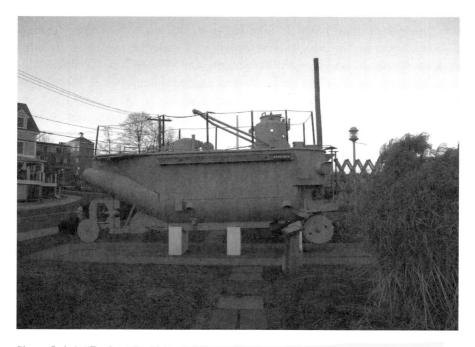

Simon Lake's "Explorer," which would be tethered to a ship on the surface and could be used in salvage operations. The craft is now at the Milford Lisman Landing. *Photo by Nancy H. Juliano.*

## Ambassador Edwin F. Stanton

Like Peter Pond, Edwin Forward Stanton didn't spend much time in Milford. A career U.S. Foreign Service officer, Stanton got his first overseas posting in 1924. He had been born in upstate New York and hadn't lived in Milford to that point.

Appointed U.S. vice consul in Kalgan, China, he served for two years in the area, the site of the Boxer Rebellion two decades earlier. During Stanton's posting there, Kalgan was drawing large numbers of Christian missionaries.

Stanton was appointed U.S. consul in Tsinan, China, in 1927 and was transferred to the American consulate in Shanghai in 1938, just as tensions between the Chinese and Japanese were reaching their highest level in the prelude to war.

He was appointed U.S. consul general in Vancouver, British Columbia, in 1945 and became U.S. minister to Thailand in 1947. Later, Stanton's office was upgraded to ambassador to Thailand by President Harry S Truman. A term on the prestigious U.S. Council on Foreign Relations in the 1950s closed out Stanton's career. He moved to Milford in retirement with his wife, who was from the area. Stanton died in 1968 and is buried in Milford Cemetery.

## The City's Mayors

For most of its long history, Milford had been governed by the town meeting, at which voters decided issues directly. Later, the representative town meeting (RTM) was an attempt to limit the input and impose control on what had become an unwieldy process.

Selectmen, headed by a first selectman, formed the executive branch under the RTM system. In 1947, a charter revision gave much of that authority to a professional city manager. By 1959, postwar growth and development pressure had raised taxes so much that voters demanded more accountability. The office of mayor was created, and the Board of Aldermen, a legislative body, was created to assist and approve the executive's actions.

City Manager Charles Iovino appeared to be left out in the cold. Iovino had decided to stay in town and to seek the top job, but neither political party would nominate him. He then ran as an unaffiliated candidate, but five days before the election, Iovino lost his place on the voting machines because it was ruled that his petitions had been filed too late.

The city's first mayor, Charles Iovino, was elected as a write-in candidate in 1959. *Courtesy of the City of Milford.*

Undaunted, Iovino declared himself a write-in candidate and distributed the pencils to get the job done. Voters had to lift a little metal tab and write in Iovino's full name. The sound of those tabs opening was heard all day. He won the election with 5,305 votes plus 258 that were disallowed because voters had written only "Iovino" and moderators said that could have meant the candidate…or his wife. Democrat Albert P. Stowe received 3,975 votes and Republican Henry Foran 3,088. State officials say that Iovino's victory appears to be the only time that a write-in candidate has won a contested election in Connecticut.

Iovino served two terms, losing to Democrat Alan H. Jepson in 1963. Iovino then became the city manager of Norwich, Connecticut, for many years. He died in September 2009 at age ninety-nine.

While the first mayor's major accomplishments were the attracting of the Schick Corp. and the sewer system the company required before it would relocate from New Jersey, Jepson brought urban renewal and modern city planning. Under his administration, the city acquired the 330-acre Eisenhower Park—a former seed farm—using federal funds. Jepson's administration also began the process of replacing unheated shorefront cottages with public housing.

When Jepson was defeated for reelection in 1969, he managed a large commercial laundry and then served as a state auditor of public accounts.

He returned to Milford government in the mid-1980s as the city's block grant coordinator. Jepson was elected city clerk in 1987 and won eleven terms before retiring from public life in November 2009.

Jepson's successor, Edward J. Kozlowski, served from November 1969 until he resigned in March 1971 to become state commissioner of public works. He later headed the state Department of Motor Vehicles. Kozlowski introduced the concept of "mini-parks," creating several small neighborhood playgrounds. He also steered the city away from a plan to build a multimillion-dollar incinerator next to the Indian River.

Clifton Moore, a Republican alderman, finished Kozlowski's term and won one of his own in the next election. Contract squabbles between his administration and the city's police and fire unions scuttled his political career. Moore is now deceased.

Joel Baldwin, who had been tax collector, won the office in 1973, becoming the city's youngest mayor at age thirty-six. The Democrat presided over Milford's observances of the American bicentennial and secured federal funds to build new headquarters for the police department on the Boston Post Road. His administration also saw the construction of a new public library and the Milford Senior Center, both also built mostly with federal funds. Baldwin served until 1977 and then became the city's director of human services before retiring in 2007.

Republican Henry Povinelli, a former state legislator from the Devon area, won the mayor's office from Baldwin and served two terms, losing in 1981 to Alberta Jagoe, then a business teacher at Trumbull High School who served on Milford's school board. Povinelli has since died.

The keynote of Jagoe's tenure was renovation. The 1916 City Hall received a historically sensitive refurbishment, and the former Milford High School, opened in 1951, became the Parsons Government Center to house municipal offices. Jagoe also gets credit for opening the Margaret Egan Center, a city recreation department facility in a former school, and getting a new sewage treatment plant built. She helped secure state funding for a public housing complex for the elderly that was later named for her. Jagoe currently serves on the Board of Police Commissioners. The Democrat said that she decided not to seek a fifth mayoral term "because I wanted to walk out of City Hall on my own, not be thrown out," something only Kozlowski had accomplished before her.

Republican Frederick L. Lisman, chairman of the Chemistry Department at Fairfield University, was elected the city's eighth mayor in 1989. He took a sabbatical and never returned to full-time teaching. He won a record six terms before stepping down in 2001.

Lisman died four years after retiring, losing a lengthy battle with cancer. He said that Storm Beth—the December 1992 nor'easter with the same name as one of his daughters—spurred improvements to the city's early flood-warning system. A U.S. Army Corps of Engineers project to elevate about sixty houses on pilings and out of harm's way came about through the mayor's efforts.

The Orchards, a nine-hole municipal golf course on North Street, and a city-owned marina on the harbor were two of the larger projects completed during the Lisman years. The mayor was the main proponent of the plan to turn what had been a sewage treatment plant into a waterfront park with docks, boat slips and snack stands. The Head of the Harbor development was named in his honor in 2005.

Republican James L. Richetelli Jr. is the city's current mayor, winning his fifth term in November 2009. A Milford native, he was elected to public office for the first time in 1985, when he was twenty-three years old. Richetelli won a seat on the Board of Aldermen that year after organizing a community effort to clean up Ralph Clarkson Field, a Little League baseball diamond. He became the board's chairman in 1989.

Chapter 4

# THE BEACH NEIGHBORHOODS

## WOODMONT

Albert Einstein may be the most famous summer visitor to the borough on the eastern edge of the city, but it doesn't take a genius to figure out why people come to Woodmont. It has been a farming community, a posh beach resort and, finally, a middle-class neighborhood of about 1,750 year-round residents. But before there was a borough—a political subdivision chartered by the state legislature—there was a Woodmont. Native Americans would collect oysters and clams there and would fish from the rocky shore. White settlers began farming, herding cows down dirt roads until the early twentieth century. One of Milford's largest remaining farms, owned by Mary Treat and her family, is still a focal point of the community.

Early maps show the neighborhood that is now Woodmont as Burwell Farms, and in the beginning at least, the name fit. The Robert Treat Farm has fields on both sides of New Haven Avenue, a nursery and a produce store facing Merwin Avenue. The family business hosts a popular farmers' market in the summer that draws vendors from all over the state.

The "trolley era" from 1890 until 1937 started a real estate boom in Woodmont. Large hotels—even a "sanitarium for the cure of 'nervous disorders'"—soon catered to flocks of visitors. It was at one of these hotels, the Bon Mar, that Einstein stayed during several summers because he enjoyed the tasty mackerel served there.

Governor Joseph Hawley, who had been a Civil War general and was later a U.S. senator, also favored the borough with several visits and apparently made a lasting impression: one of the major streets is named for him.

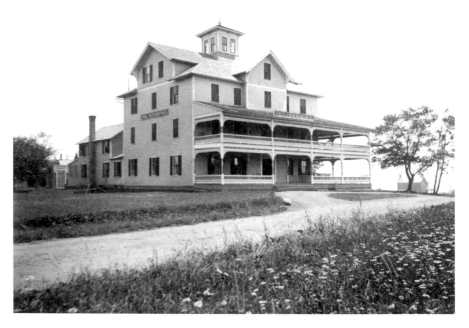

The Pembroke Hotel, a Woodmont vacation spot. *Courtesy of Katherine Krauss Murphy.*

Two very different words, "quaint" and "vibrant," are frequently used to describe Woodmont. Among the borough's several mid-twentieth-century hotels were the elegant Sanford House and the Pembroke Hotel, which trumpeted in a 1939 ad the addition of a Grill Room and buffet service. The Woodmont Country Club was once the center of the social scene. Tennis and croquet were popular pastimes at the New Haven Avenue facility. A speakeasy operated at the corner of Chapel Street and King's Highway during the 1920s Prohibition era.

The Woodmont Civic and Recreation Association now stages the annual midsummer block party and parade known as Woodmont Day, along with an ice cream social, Christmas tree lighting and other events. The association also drew about 150 residents to the Signal Rock flagpole in May 2003 for a 100th anniversary photo. The residents stood in the same place the founding borough residents had a century earlier.

While anti-Semitism was a shameful attitude in some other Connecticut resort areas, Woodmont did not discriminate and was welcoming to people

Guests at Woodmont's Pembroke Hotel were promised many amenities in this mid-century ad. *Courtesy of Katherine Krauss Murphy.*

Woodmont public beach access, at the foot of Dixon Street. *Photo by Nancy H. Juliano.*

of different faiths and ethnicities. With an open-heartedness rare in its day, Woodmont became known as a Jewish enclave for New York City residents trying to escape the summer heat. For many years Burwell Beach, just outside the borough, was known locally as "Bagel Beach."

## MORNINGSIDE

The Morningside neighborhood may be Milford's best-kept secret. The once-gated community has no through streets, and although its beach is open to the public, few wander down the narrow roads to visit. Most Milford residents are familiar with the two fieldstone trolley stops on Edgefield Avenue that mark the neighborhood. They are all that remains of a trolley line, the Connecticut Light Rail Co., which once ran from New Haven to Bridgeport. When the line was abandoned, the right of way was divided between the city and the Morningside Association.

A hidden gem is the spectacular vista of Long Island Sound along Morningside Drive, perhaps the highest unobstructed view of the sound along the state's coastline. The present neighborhood with about two hundred houses started as the private Shangri-La of a wealthy industrialist, Henry G. Thompson. He bought sixty acres and built a large house and

The Morningside Drive vista. *From the Henry "Buster" Walsh postcard collection.*

several outbuildings in the early 1900s but spent little time there. After a fire destroyed many of the Thompson buildings, the Yale Land Co. bought the Morningside estate, divided it into building lots and began selling them in 1921.

The neighborhood was marketed as an exclusive summer resort until the 1929 stock market crash, and the Great Depression that followed put a stop to that. The Hurricane of 1938 drove away a few more early buyers. It took the Baby Boom years and the demand for housing following World War II to really launch Morningside as a year-round community.

The original developer got a state charter for a neighborhood association similar to the one governing Laurel Beach on the western end of the city. It created a quasi-municipality with the authority to levy taxes and take land by eminent domain. The Morningside Association owns some land, including a recreation field with tennis and basketball courts and the flagpole that is a focal point of the community. It is outfitted with a message board that supplements the neighborhood newsletter.

Another amenity that the association provides to residents is the large raft that replaced "The Rock," a big boulder that gave Rock Road its name. A committee plans picnics, holiday decoration contests and events for children, including an annual Easter egg hunt.

## WALNUT BEACH AMUSEMENT PARK

The neighborhood at the foot of Naugatuck Avenue has gone through many changes, most recently from a slightly seedy area of bars and vacant storefronts to a burgeoning arts district with restaurants, shops and upscale condos.

But it was the Walnut Beach that flourished "between the wars," from the 1920s until the mid-1940s, and hung on for another twenty years after that, that is most fondly remembered. The "beach kids" who grew up there recall movie theatres and night clubs, an amusement park and a "stadium" for sporting events, skating rinks, dance halls, candy stores and hot dog stands. It is still possible to see faint traces of this old Walnut Beach in building façades and decorative arches.

Several amusement parks with rides, a midway lined with games of chance, dance halls and boxing rings once flourished here. It started with Harrison Park in 1920 and Walnut Beach Park, opened by the Whitham family in 1924. The salty tang of the air at Walnut Beach had to compete with smells

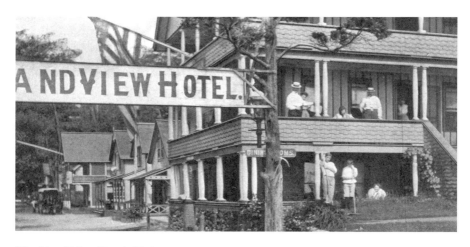

The Island View Hotel. *Used with permission of the Thomas J. Dodd Research Center at the University of Connecticut.*

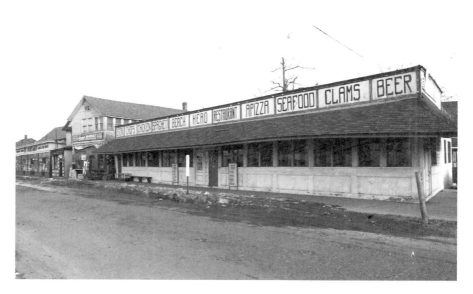

The Beachhead Restaurant, closed for the season. *Courtesy of the Myrtle Beach–Walnut Beach Historical Association.*

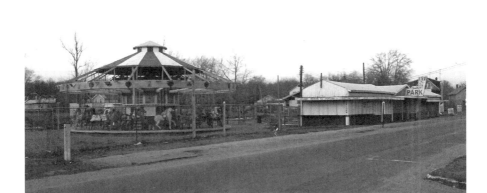

Smiths' 17-Acre Park in the off-season. *Courtesy of the Myrtle Beach–Walnut Beach Historical Association.*

of fried dough, cotton candy and hot dogs for most of the first half of the twentieth century, with the amusement parks, the Beachhead, Pat and Lou's and Penuchie's selling hot dogs, fried clams and other "beach food."

The most fondly recalled amusement area was Smiths' 17-Acre Park, which featured bumper cars, a carousel (called "the flying horses" by those seeking to grab the brass ring), miniature boats and planes and kiddie rides. Two brothers, Les and Frank, ran the park, and their children—including Linda Smith Stock, the current city clerk—all had the dream summer job at one time or another. The Smiths also operated a popular skating rink. The Beach Shore Village condos are on the site of the Smiths' park, which closed in the mid-1960s.

When local boy Alfred "Red" Moffett knocked out Julius Kogan of New Haven in the Walnut Beach Stadium in the late 1930s, it was the high-water mark for professional boxing here. Milford's Moffett was the underdog that night—as he was for many of his fights—despite a 47–4 career record. Milford boys weren't supposed to be as tough as New Haven or Bridgeport kids, Moffett said, "but I discovered that I could beat up guys my size and many who were bigger than me."

The crucible of poverty and desperation that was the Great Depression led many young men into prizefighting for as little as five dollars a bout

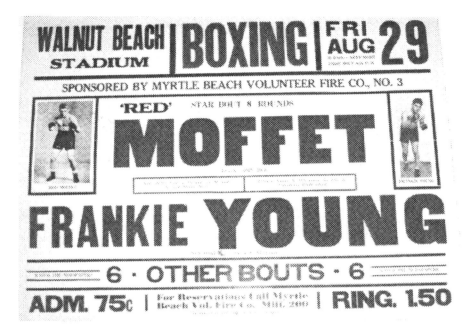

A 1930s poster for the "fight card" at Walnut Beach Stadium has Milford resident Alfred "Red" Moffett in the main event. *Courtesy of the Myrtle Beach–Walnut Beach Historical Association.*

or a wristwatch. Boxers like Moffett and Anthony "Abe" DePalma of New Haven would travel throughout the state for a bout on an evening's "fight card."

Moffett, who died in 2005, said that when he joined the U.S. Navy in World War II, that put an end to his boxing career. "It wouldn't have been fair," he said. "I had all that experience." Moffett later joined the Milford Police Department, was decorated for bravery and started the city's Police Athletic League, where he taught youngsters to box.

As much as boxing, amusements and the water itself, Walnut Beach drew visitors for its nightlife, offering nightclubs with professional entertainment and taverns with dance floors competing for business.

Trains from Waterbury and New York would bring tourists into a nearby station in the early years. Later, as cars became the preferred mode of transportation, summer guests would pull up in front of the large wooden hotels for a weekend or a week. So many came from the Waterbury area that the street now known as Shorefront was called Waterbury Avenue. When the city succeeded in having an abandoned and dangerously decrepit hotel

Smiths' Roller Rink at Walnut Beach was owned by brothers Frank and Les Smith. *Courtesy of Linda Stock.*

on that corner torn down and replaced with condos in 2002, it marked an important transition in the neighborhood.

There had been others. The "Long Island Express," as the great hurricane of September 1938 became known, dealt only a glancing blow to the western Connecticut shoreline but here tore up piers, beach cottages and amusement park sheds and tossed the pieces onto the streets like kindling. A fire early on New Year's Day 1953 destroyed the Emerald Room, which had been packed with revelers only hours earlier.

The closing of the Walnut Beach School—whose alumni still hold reunions—was another marker in time. By the early 1960s, many of the mainstay businesses had closed, including the Photo Mart, the Beachhead, Primrose's Market and Diamond Hardware.

A decades-long sleep followed, and the neighborhood's most recent incarnation—as an arts district—began in 1999 with the conversion of a former firehouse into an art gallery managed by the Milford Fine Arts Council. A fishing pier was built a few years later and dedicated to Albert Munroe Sr., who had been an avid fisherman all of his life. The colorful

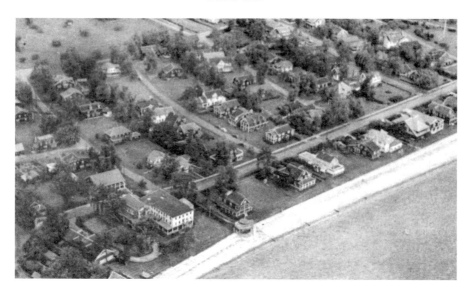

Aerial view of Laurel Beach. *From the Henry "Buster" Walsh postcard collection.*

Munroe owned a taxi company and later served his neighborhood as an alderman.

The city purchased the former Stowe Farm in 2002 and plans gallery and studio space in a barn and possibly a small stage and rehearsal area. A $1 million state grant and other funding is being used for the project, which could open in 2012.

Former alderman Joseph Garbus, who now chairs the neighborhood improvement association, was probably the first to talk about an arts district in 1997. Early in 2010, Garbus watched as piles were driven into the sand for the Walnut Beach Boardwalk, one of the state's longest. "Things eventually get done," he said that day. "You just have to be patient."

## LAUREL BEACH

People in Laurel Beach can tell you who lived in the houses there twenty or even fifty years ago. Some of the "cottages" even have names of their own, like the Bluebird Cottage on Sixth Avenue. The neighborhood also has its own casino, which is the social heart of the shore community at the western end of Milford.

Phrases like "subdivision" and "planned community" have taken on a negative connotation in present-day Milford, but that's exactly how Laurel

Beach got started. It was created in the late 1890s on land that had once been the Merwin Seed Farm.

Two Waterbury developers hired Stanford White, the famed New York City architect who designed the first Madison Square Garden, to lay out the streets. All of them are bowed a bit to give nearly every one of the 195 homes a view of Long Island Sound. Laurel Beach is also laid out to take advantage of its best asset, the stretch of sand from First through Eighth Avenues. The neighborhood is only two or three blocks deep, ending where Milford Point Road wraps around the back of the casino.

The casino is more of a clubhouse and gathering place than anything else; it is not a gambling hall. It is open for a few hours a day in July and August for the youngsters, who can play ping-pong, bowl or enjoy other activities. A large ballroom hosts dances and other social events for the grownups, and tennis courts stretch out behind the facility.

If the lawns seem meticulously cared for, it's because residents pay a common charge to the association that covers mowing, clipping and even raking leaves. Some property owners spend only a few weeks here in the high season, so the last thing they want to do is yard work. The common fee is

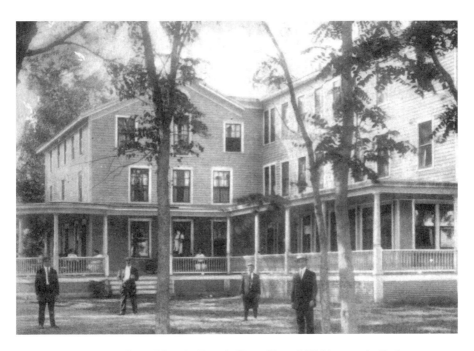

The Elsmere Hotel on Laurel Beach. *From the Henry "Buster" Walsh postcard collection.*

based on the city's assessment of each property's value for taxes. Upkeep of the casino, tennis and bocce courts and athletic fields, the Laurel Beach Green and sea wall are included, along with the landscaping service, for an average annual fee of between $700 and $1,400, officials said. The association also owns a series of passageways—former bridle paths—between the streets, providing a "back way" to almost everywhere in Laurel Beach.

Neighborhood historian Frank Smith, in preparing for the 100th anniversary of Laurel Beach in 1999, found a seventy-year-old rulebook that sounds quaint to modern ears. "Domestics [servants] are not allowed on the beach at high tide unless they are caring for children," is one of the rules.

# Chapter 5

# A FIRST-CLASS EDUCATION

## LAURALTON HALL

Lauralton Hall opened its doors here in 1905, in what had been the Pond-Taylor Mansion, and the college preparatory school for young women has since graduated generations of female leaders, business executives and media specialists. Early graduates got a rigorous education along with lessons in how to run a gracious and comfortable home, and as society changed over the years, so did the parochial school.

By removing the social pressure—and the competitiveness—that is part of a coed high school, the Academy of Our Lady of Mercy (its formal name) gives female students a chance to shine.

Lauralton Hall is now a day school offering high school grades only. Students don't wear beanies to chapel anymore, and the "Angel Dorm"—the third floor of the main building where girls as young as four once roomed—is now administrative offices.

The boarding school closed in 1956, and kindergarten and the eight primary grades were dropped at about the same time. The Sisters of Mercy, a religious order dedicated to the education of young women, staffed and ran the school for much of its existence. There are now only three nuns on the faculty, though Lauralton continues to be owned and sponsored by the Sisters of Mercy. Since 1973, the school has been managed by a board of trustees made up of men and women from the education, banking, law and business fields. It also comes under the auspices of the Archdiocese of Hartford.

The cheerleaders now cheer for Lauralton's own Crusaders sports teams, not for the young men at Fairfield College Preparatory School, as they had

1940s chemistry lab, Lauralton Hall, Academy of Our Lady of Mercy. *Courtesy of Lauralton Hall.*

for years. The annual fall musical draws so many people from the community that years ago the production was moved from campus to the nine-hundred-seat Parsons Center Auditorium. The Advanced Vocal Chorus, once known as the Lauralettes, has performed in New York City and in Washington, D.C.

But in all the important ways, Lauralton Hall has not changed a bit. Virtually all of its graduates go on to college, and its athletic teams frequently win conference and state titles, particularly in softball and basketball. Individual athletes have competed on the national level in swimming and diving. The demanding curriculum includes offerings that public high schools don't have, including several foreign languages, instrumental music, advanced math and vocal performance and theatre arts. Students are

Chapel at Lauralton Hall, Academy of Our Lady of Mercy, probably in the 1930s. *Courtesy of Lauralton Hall.*

required to do community service projects and to take religious education courses. In recent years, Lauralton students have been active in the Invisible Children campaign to raise awareness of civil wars in central Africa.

A popular summer program brings younger inner-city girls to the thirty-four-acre campus for mentoring and enrichment courses. Recent improvements to the campus include the conversion of a basement area into a state-of-the-art science lab and the opening of the school's new field house. The former gym was converted into a library. Lauralton's trustees have embarked on a project to restore a historically significant barn.

About 30 percent of the present faculty is Lauralton alumnae. Among its most prominent graduates is U.S. representative Rosa DeLauro, the veteran Democratic congresswoman from the Third District. "The years I spent at Lauralton Hall were the best years of my life," DeLauro said. "It was there that I learned to nourish my mind and my heart, to reach out, to work hard, to fulfill my potential and be whatever I wanted to be. I am closer with the friends I made at Lauralton than those I made in college."

When the Sisters of Mercy established the Academy of Our Lady of Mercy, the Pond-Taylor Mansion, the school's centerpiece, was the only building. Two classroom buildings were opened soon afterward. Mother M. Augustine Claven, mother superior of the Sisters of Mercy, purchased

the mansion in spring 1905, and the first classes at Lauralton were held on September 12 of that year. The current enrollment is about 430, school officials said.

Area alumnae have sent their daughters and granddaughters to Lauralton. Through the years, in keeping with the school's philosophy that women can do anything, graduates have distinguished themselves in the fields of medicine, sports, performing arts, journalism, law and paleontology.

Jennifer Smith, who lived in Trumbull when she attended Lauralton, was part of a research team that identified a dinosaur species, school officials said. Other notable alumnae include Cynthia Kennard, class of 1972, who has worked in the London and Moscow bureaus of CBS News; Judith Lisi, 1964, the former head of the Shubert Theater Foundation in New Haven and president of the Tampa Bay Performing Arts Center; and Marcia Kiesel, 1975, cookbook author and director of test kitchens for *Food and Wine* magazine. Marcia Frederick, the gymnastics gold medal winner at the 1980 Olympics; Kathleen Lenihan Nastri, the first woman president of the Connecticut Trial Lawyers Association; and Mary Morgan Wolff, warden of the Webster Correctional Institute in Cheshire, all graduated from Lauralton.

To connect with its far-flung alumnae network, Lauralton has an annual magazine and a blog for graduates on the school's website.

## THE MILFORD SCHOOL (ACADEMY)

Known at various times as the Milford School, Milford Academy and Milford Prep, the private school thrived for nearly a century by sending graduates on to elite universities and helping athletes become eligible to play NCAA college sports.

Founded in 1916 by two Yale graduates, Harris and Samuel Rosenbaum, the school was meant to provide a "classical" education, stressing Latin, physics, literature and higher math, including trigonometry.

The Gulf Street school attracted students from all over the world but especially from South and Central America. It is the alma mater of actors Vincent Price and Efrem Zimbalist Jr. John Schmeding, a Milford Academy and Boston College graduate, played for the Buffalo Bills in the NFL. Legendary Yale football star Albie Booth was an early graduate.

Students from "the Milford School" didn't associate much with "townies" going to public high school here, 1965 graduate James Beard said. Sports

rivals were other Connecticut prep schools, especially Cheshire Academy, and the Milford Prep Falcons, as they were known, played many games against college junior varsity teams.

There never was a formal arrangement with Yale University to grant admissions preference to Milford Academy graduates, said David Rosenbaum, the son of a founder. But Ivy League institutions and private liberal arts colleges snapped them up, he said. Students, all male until the 1970s, were required to wear jackets and ties to class.

At various times in its history, the private school offered elementary grades and college-level courses, vocational training in such fields as culinary arts and an international language summer institute and also leased space to a day-care program and a theatre. Beginning in the mid-1970s, Milford Academy began to emphasize the postgraduate, or "thirteenth-grade," program it always had and to market it as a way to prepare high school athletes to accept major college scholarships.

That led to a subtle but important shift away from academics that, combined with some questionable management and declining enrollment for traditional prep schools, spelled the end for Milford Academy. Beard and other alumni said that the school also didn't capitalize on a traditional source of funding and endowments—its successful graduates. Through the years, alumni got only sporadic mail from the school, and only one formal, official reunion was ever held.

The city bought the academy's indoor pool and several athletic fields to help keep it financially afloat in the late 1990s, and a few years later the city bought the rest of the eleven-acre campus for $2.5 million. The land was sought by developers, but the community campus lives on, now housing the city's Department of Human Services in the administration building and the Milford United Way in the former dining hall.

And education also continues at the site. The alternative public high school, now named The Academy, occupies the main classroom building.

## THE THREE MILFORD HIGH SCHOOLS

The local public high school that began in 1842 had several homes before disappearing—in name only—in 1983. The glass cases full of trophies, banners, yearbooks and prom pictures in the Thomas Parsons Government Center, and the thousands of alumni who come back for Milford High School's "All Class Reunions," demonstrate that school spirit is still vibrant and strong.

When the secondary education classes were offered in the late nineteenth century in a wing of the old Town Hall building, it meant that local students could get the same first-class education available to young scholars in Bridgeport and New Haven. But few took advantage of the opportunity at first. Milford was still a rural farming town where Latin wasn't as useful to know as animal husbandry.

After the first dedicated high school building was opened in 1908, attendance rose steadily through the years as young people trained for jobs outside of the family farm. The yellow brick building on West River Street served for more than forty years and later was converted into apartments for the elderly, many of whom had prowled the same halls cradling textbooks decades earlier.

The "new" Milford High School, a sprawling red brick complex, opened in 1951, and when the building was converted to municipal offices more than thirty years later, traces of its former use remained. Some facilities, like the auditorium and the gymnasium, still host the same type of events

The "new" Milford High School on West River Street was hailed in 1908 as one of the first brick buildings in the city. *From the Henry "Buster" Walsh postcard collection.*

An undefeated season, and one of the last, for the Milford High Indians basketball team. *Courtesy of the City of Milford; photo by Nancy H. Juliano.*

as they did when the Milford High Indians were the dominant power in the Housatonic League.

Others remain because it was easier to incorporate them. The walls in some of the main corridors bulge out several inches to accommodate the metal lockers still bolted to the studs behind them. Covered with new sheetrock, those lockers are still inscribed with couples' names drawn in hearts, boasts about sports and probably a few negative comments about teachers who assigned too much homework. So far there have been no complaints about ancient lunches entombed behind the walls.

Easier to see are the memorabilia preserved in the lobby, including the leather footballs from the 1920s painted with the winning scores in championship games, the banner from the 1978–79 basketball team's remarkable 20–0 season and copies of the student newspaper.

Journalist Jim Rose and his son Tim organized the first reunion for all Milford High graduates in 1983 to mark the school's closing. Underclassmen that year finished their education at Joseph A. Foran High School on the east side of the city.

When Jonathan Law High, at the time the city's second high school, opened in Devon in 1961, some Milford High students were shifted to that

building. But in both cases, students who began at the downtown Milford High received diplomas with that school's name on it when they graduated.

The committee that organizes the all-class reunions every five years has a database of ten thousand names and phone numbers of alumni and uses websites like Classmates.com to find more. Another source, organizer Robert Gregory said, is the "popular kids."

Every class had them: the cheerleaders, jocks, class presidents and student council leaders who kept up with classmates through the years, Gregory said. Alumni from as long ago as the class of 1934 and from as far away as Florida attended the last reunion, in 2008.

The maroon and white championship banners and the tall, shiny trophies are a particularly noteworthy achievement for a high school that until 1951 played its home games in the grammar school next door, graduates said.

Richard Platt, a member of the class of 1951, the last to spend all four years in the old yellow building, said the grammar school gym had an overhanging balcony and sometimes errant shots would hit it instead of the

Faded Milford High pennants in maroon and white from the early twentieth century. *Courtesy of the City of Milford; photo by Nancy H. Juliano.*

hoop. "It was tight in there," he said of the grammar school gym, which stood about where the Parsons Center parking lot is now.

The same might be said of Platt's entire high school career, which was spent in double-sessions to ease overcrowding. "The junior, senior and the sophomore boys would go in the morning, so the sophomore boys would be available for sports. The freshmen and the sophomore girls had classes in the afternoon," the city historian recalled. "The new high school was finished in the middle of my senior year, and we got to use the band and chorus rooms."

The class of 1951 was also scheduled to inaugurate the auditorium with its commencement exercises. "That was close; they were installing the seats while we were rehearsing," Platt recalled.

Many of the places that Milford High students used to congregate at are gone. Paul's Hamburgers, a hangout for decades, closed in 2008. The Capitol Theater on Daniel Street, where many students had their first dates and first kisses and even played hooky, was torn down in the mid-1990s. The soda fountain in the Milford Pharmacy at the corner of River Street and New Haven Avenue was replaced by an office building in the 1970s.

Gregory, the city's economic development director, said that while he is nostalgic for many of the places of his youth, he is certain that his high school building will remain. The city official works in the Parsons Center, the building he once attended classes in. "No one's going to take this away," he said.

## MISS FANNIE BEACH

Fannie Beach's forty-five-year career in education here spanned the era from the one-room schoolhouse to the modern brick classroom building with its all-purpose room. She began in 1891, teaching all of the primary grades in a "schoolhouse" that still exists on a different location on Chapel Street. It was converted to a private home years ago with the addition of sun porches and rooms on each side. The middle portion, though, still recalls its first use—and the stern-looking woman who would stand outside on weekday mornings in a long dress, greeting her students and watching for stragglers.

In those days, according to Fannie's niece Ruth Beach Sykes, Woodmont and Milford felt like very different places, separated by a half-hour journey in a horse and buggy over bumpy dirt roads. "The worst part of the four-mile trip was Eells Hill, a sharp curve that was dangerous to take quickly," Sykes wrote in her 1996 autobiography. "We didn't go into Milford much."

Miss Fannie Beach and her students at the one-room schoolhouse in Woodmont, prior to 1918. *Courtesy of the City of Milford.*

It's likely too that the nascent Board of Education didn't keep too close an eye on Fannie Beach or her students. Known for their deportment and academic ability, her young charges were more than ready when they moved on to the middle grades at Central Grammar in Milford. In 1918, the "new" Woodmont School opened on Dixon Street, and Beach became its first principal. No longer the only teacher, she supervised a faculty that learned from her as they taught their pupils. Fannie Beach lived on the family farm, across New Haven Avenue and about a half-mile from the school. Her home was roughly where the Webster Bank on Merwin Avenue is now.

She retired in 1936, and in 1970 the city renamed the Woodmont School in her honor. During the intervening years, a large white "portable" classroom had stood to the left of the main building on what is now a parking lot. That wooden annex itself was larger than the first school that Fannie Beach had taught in. The school closed in 1979 due to shifting enrollment and is now the Fannie Beach Community Center. A large portrait of the educator welcomes visitors to the building.

# Superintendent Joseph A. Foran

No one would have picked Joe Foran as "most likely to succeed" when he was a student. In fact, his teachers at Milford High told Foran's parents that he might do better in the working world. So the man who would later become the superintendent of schools here and leave an indelible stamp on the city dropped out at fifteen and went to work in a meat market.

Feeling dissatisfied and restless, he accepted private tutoring from a Milford Academy teacher who had befriended him. Next, Foran took the exam for the U.S. Military Academy at West Point. Despite not having a high school diploma, the young man had the highest score on the test that year. Even that didn't get him the appointment, so Foran applied to his "fallback" school, Yale University. He was admitted in the fall of 1933, the very nadir of the Great Depression, and graduated at age thirty. Foran's aunt had been a teacher, so he entered that field, quickly became an administrator and was appointed superintendent in 1946.

His twenty-year tenure coincided with the peak years of the Baby Boom, and Foran got new elementary schools built in every section of the city. If they all look vaguely the same, it is because the frugal superintendent purchased one architectural plan and simply oriented the building in the most suitable way for the lot. He also left room for new classroom wings, which were added by the 1960s. Calf Pen Meadow, Orange Avenue, Mathewson, Live Oaks and John F. Kennedy Schools were built while Foran was superintendent and are still in use today.

Throughout his career and his long retirement, Foran's piercing blue eyes and fierce intelligence made him a sought-out friend, adviser and confidant. His daughter Monica recalled that her father was sometimes condescended to by school board members who were unaware of his Ivy League education. "My dad was not a complainer, even though I am sure that he had plenty to complain about," Monica Foran said. "He handled those who gave him the most difficulty by turning the other cheek. He would not ignore the slight or argument; he just knew the difference between conflicts of opinion and conflicts of personality. Some of the people he respected most were often those with whom he had a conflict of ideas," she said.

When the city was preparing to build its east side high school in the early 1970s, Foran's name was the only one seriously considered. He accepted the honor with typical grace and celebrated his ninetieth birthday in the gymnasium in 1996 with family, friends and the students of "his" school.

Portrait of Joseph A. Foran, superintendent of schools from 1946 to 1966. *Courtesy of the City of Milford.*

After his retirement, Foran served on the Board of Education, where he continued to work in building a school system worthy of the people of Milford. Years before it was a management style taught in business schools, Foran used the "shared leadership" model of acknowledging and praising the work of assistants and employees.

"He tried to help people through their trials and tribulations, listening carefully and trying to suggest solutions without telling them what to do," Monica Foran said. In every sense, Joe Foran was a self-made man.

## ARNOLD COLLEGE

The phys-ed teachers who came out of Arnold College, many of them attending on the GI Bill in the years following World War II, taught generations of area school kids the intricacies of dodge ball and square dancing. But they did a lot more than that. Graduates of the four-year college in Point Beach also coached intramural and varsity sports, became administrators and principals and along the way managed to instill the values of good sportsmanship and perseverance.

# A First-Class Education

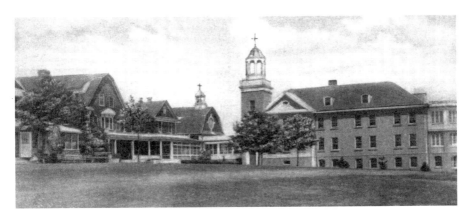

Campus of Arnold College, late 1940s. *From the Henry "Buster" Walsh postcard collection.*

All of the graduates of Arnold College—the nation's first coeducational school of physical education—have retired from their careers. The school was merged into the University of Bridgeport in 1953, losing its identity and its Milford campus. The property later became the Pond Point Nursing Center and, a few years ago, sprouted seven $1 million luxury homes.

Arnold College produced Vito DeVito, who coached baseball and basketball at all three Milford high schools for thirty-five years and served as Yale University's freshmen football coach for much of that time. Vito Montelli, whose basketball and baseball teams at St. Joseph High in Trumbull became regional powerhouses, is also a graduate. So were Frank Crisafi, Charles Conte and Arnold Cestari, coaches for East Haven High's strong teams in the Housatonic League. Cestari later became principal of East Haven High School.

Other illustrious alumni included Andy Robustelli, who played for the New York Giants in the NFL during their championship years in the late 1950s and early 1960s; Sal Verderame; and Roy Lund and Tuffie Maroon, both well-known Milford coaches and athletic directors.

Ironically, Arnold College teams would routinely play—and handily beat—the University of Bridgeport. "We'd beat them all the time," said Joseph DiDomenico, an Arnold College alumnus. "We used to say that UB couldn't beat us, so they bought us." The merger, which happened without warning just before the fall 1953 term opened, is still the source of some bad feeling among area graduates.

Arnold College students had to finish their education in Bridgeport, alumnus Harry Knowles said, and coaches and teachers scattered to

take new jobs all over the state. Graduates nearly sixty years after leaving Arnold can still name their instructors and fondly recall them as always willing to help.

Mary Grandy, Martine Gilbert and coach Ray Subiak, who taught classes of twelve to fifteen students, "inspired us," DiDomenico said. After graduation, DiDomenico went on to coach and teach biology at St. Mary's High School in New Haven for many years.

The college was named for an orthopedic surgeon from New York who started it in New Haven in the 1920s. It moved from Chapel Street near St. Raphael's Hospital to Milford during the war.

Arnold College was co-ed, but there weren't enough women to field varsity teams in many sports, Knowles said. Instead, the women had a number of "club" or intramural teams to compete on. The "Townie Inn" was the lounge reserved for female commuting students at Arnold, and there were women's dorms, or "cottages," as the white wooden houses were known.

Leafing through the school's yearbook, the Arnold College *Wave*, is a poignant experience. There are photos of proms, homecoming dances, musicals, the Water Carnival and extracurricular activities like the Blood Donors Club. All of the ads are for long-gone Milford businesses. The telephone numbers have only five digits.

But it is the sports scores that really catch the eye. In 1952, Arnold College played Fordham, Adelphi, St. John's, Iona College, St. Michael's College of Vermont, Bryant College, Siena, Fairfield and the University of Connecticut in several sports and won most of the contests.

The school had no home field for baseball or football; Arnold teams traveled a lot and played some games at the city-owned Washington Field on the Boston Post Road. "We didn't care where we played as long as we got to play," said Knowles, who later starred for the West Haven Sailors, a semi-pro baseball team. "I was a nineteen-year-old kid playing with twenty-five-year-old guys who'd come back from the war. I was in awe."

Chapter 6

# LEGENDS AND NOTABLES

## George Washington's Silver Spoon

Although George Washington didn't actually sleep here, one of his visits is well documented, and his stay at the Clark Tavern was rather eventful. It seems that the Father of Our Country, as he was already being called by the time of his visit in 1789, didn't make the best impression.

Washington had been serving as the nation's first president for about six months when he came through Milford on November 11, 1789. He'd been here before, about a month earlier, describing the town in his diary as having "but one Church, that is, one steeple, but there are grist mills and saw mills and there is a handsome cascade over the tumbling dams." With New York City serving then as the nation's capital, Washington would have ridden through Milford many times on his way to and from his home in Virginia.

That November morning, the president had arrived at Andrew Clark's inn, on the present site of the Parsons Government Center, in time for breakfast. He had ridden "the upper road to Milford, it being shorter than the lower one through West Haven," he wrote in his diary. Washington asked for a bowl of milk and some bread, and—maybe his wooden teeth were bothering him—the president was not happy with the spoon at his place setting. It was pewter, and worse, it was broken.

So the president called the serving girl over and demanded—his exact words are lost to time—a silver spoon. The proprietor hurried over and explained that he didn't have any silver on the premises, but it might be possible to borrow one. So the hapless serving girl was dispatched to the Reverend William Lockwood's home next door and returned with a spoon

from Mrs. Lockwood's wedding silver. The meal ended uneventfully, and after sending his thanks to Mrs. Lockwood and, hopefully, tipping his waitress, Washington saddled up and rode on to New York.

The president was hardly the only dignitary to come through town in those days, an advantage Milford had from being on the main coach road between Boston and New York. Aaron Burr, then the U.S. vice president but later to be more famous for killing Alexander Hamilton in a duel, was another visitor not happy with the service here.

The story goes that Burr, by all accounts a rather pompous and self-important man, rode through town on a drowsy Sunday afternoon, his carriage followed by an entourage of attendants. (Note that barely fifteen years before, the U.S. president had ridden into town alone.) A sentry sitting high in the belfry of the Congregational church raced out to stop the traveling party.

A contemporary account says that Burr imperiously brushed off the man, saying that he had urgent business in Philadelphia and that the sentry best get out of his way. The Milford man replied that if a man's business was more important than God's he might let Burr's party pass, but since it wasn't, the vice president and everyone else would have to wait until sundown to continue their journey. The Sabbath blue laws at the time forbid most work, so Burr grudgingly stayed in town a few hours.

And the Marquis de Lafayette, the French soldier and statesman who assisted the American cause during the Revolution, also paid a visit to Milford. He came through town in the early 1820s on his celebrated U.S. tour. Lafayette Street downtown was named in honor of his visit.

## MILFORD MARBLE

The slab of greenish stone at the corner of Cherry Street and Plymouth Place is one of the largest remaining pieces of the "verde antique" marble that was quarried here in the first decades of the nineteenth century. The quarry itself stood just off the Boston Post Road, where the Staples and Wal-Mart stores are now. But the vein of marble and limestone that ran from Georgia into Canada and had a particularly rich lode here was commercially played out within thirty years of its discovery.

The beauty of the rare green marble can be seen in the smaller pieces that remain, cut and polished to show its intricate serpentine patterns. The quarry operated here between 1811 and 1816, just in time to supply materials for the rebuilding of Washington, D.C., after the British burned

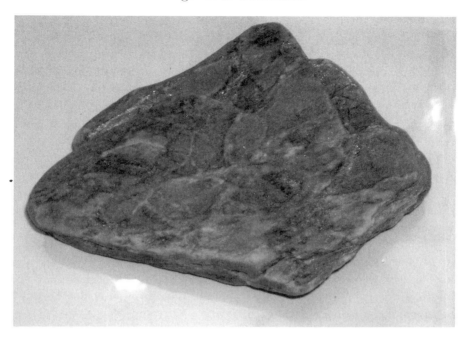

An example of verde antique Milford marble. *Photo by Nancy H. Juliano.*

the city during the War of 1812. The stone was used for decorative fascia in buildings ranging from the U.S. Capitol to the White House, where it was used to surround a fireplace in one of the public rooms.

Serpentine marble—the term refers to its geologic makeup as well as the pattern of the polished stone—still exists in small, narrow deposits stretching from Newfoundland to Georgia, geologist Scott Bailey said. There was a smaller quarry with the same quality marble in West Haven that was filled in to create the Maltby Lakes reservoir system, Bailey said in a report commissioned by City Historian Richard Platt. The green verde antique marble was prized for its beauty and rarity, but foreign competition soon made the local quarrying operation unprofitable, Platt said.

## ESCAPING SLAVES AND SMUGGLED BOOZE

Milford kept up its swashbuckling traditions into the twentieth century, smuggling contraband in and out of the city in carriages, boats and any other modes of transportation that could be pressed into illicit service.

A hotbed of abolitionist sentiment, Milford was a stop on the reputed Underground Railroad, the loosely organized network of sympathizers who would help escaping slaves cross the Mason-Dixon line into the free states of the North and ultimately into Canada, where they were not subject to bounties and recapture. Connecticut's legislature first limited the spread of slavery in 1784 by freeing all those born after March 1 of that year when they reached twenty-five years old. Slavery was permanently abolished here in 1848.

One local stop for escaping slaves almost certainly was a farm on Orange Avenue. There, a heavy fieldstone still fits tightly over the brick-lined hole where fugitive slaves may have hid. Historians believe, but cannot prove, that the eight-foot-deep pit large enough for three adults was a "station" on the Underground Railroad.

The 1820s Greek revival farmhouse was owned by the Clark family, one of Milford's founding clans, during the years before the Civil War, and the backyard pit seemed to have no other purpose. There is a root cellar elsewhere on the property. "What we believe is that escaping slaves, traveling north by night, would hide during the daylight hours in the room," Geraldine Mason, a former owner, once said.

Air and messages would be passed between the fugitives and the Clark family through a small hole in the cellar wall that leads directly into the "room." Escaping slaves would run across the fields at night or be smuggled out in wagons covered with hay, to be met by the next "conductor" leading them to safety.

There are two other possible Underground Railroad sites here. The Hubbell Mansion on Crescent Drive in Rivercliff was rumored to have tunnels from its basement leading to the Housatonic River, and the Streicker family home on Fort Trumbull Beach, which has been replaced by condominiums, had tunnels to the beach, several residents said.

The same tunnels from the Streicker homestead onto the beach were possibly used again sixty years later to bring whiskey from Canada into the area. Prohibition was enforced throughout the 1920s, though it was possible to get a drink at several clandestine Milford watering holes, including Kitty Torpey's in Woodmont. The Beachcomber Restaurant on Melba Street was also supposed to be a place where a person knowing a secret knock could have a cocktail.

Historians aren't sure that Fort Trumbull Beach was the transfer point for "the good stuff"—bonded whiskey distilled in Canada—or even the low-grade "hooch" from somebody's bathtub. But in the days before highways and with a need for secrecy, a boat between New York and here was a popular method for rumrunners.

# THE MILFORD CEMETERY

Despite their reputation for dour resignation to whatever fate handed them, the English settlers and the generations that immediately followed them told more than they probably meant to. But that information came late, on their tombstones.

Like most cemeteries that saw their first burials in the late seventeenth century, the graveyard bounded by Cherry, Gulf and Prospect Streets downtown has attracted all sorts of visitors through the years. Several years ago, a group dedicated to winning explorer Peter Pond his rightful place in history retained an engineering firm to use ground-penetrating radar to look for Pond's unmarked grave.

The Milford Cemetery rates its own chapter in at least one book on haunted Connecticut sites, though in terms of ephemeral specters, poltergeists and other restless dead, the local graveyard is a pretty quiet place.

There was a furor recently when the "Molly Stone," perhaps the most famous tombstone in the cemetery, turned up missing. Amid fears that some collector took it home to use as a coffee table, there was an all-out search for the stone of a woman who apparently didn't attract as much attention in life. And then it was found, a few feet away from the grave it marked, apparently moved by pranksters and vandals, not thieves.

In the fall of 2009, the skull of a soldier who died of smallpox here after being released from a British prison ship in 1777 was reburied with full military honors. The ceremony, organized by Thomas F. Beirne, a Milford Historical Society director, came about after Beirne found the skull listed in a 1907 New Haven museum catalogue and traced its whereabouts to the Smithsonian Institute in Washington, D.C.

Another historian, Gary Gianotti, is trying to get permission to open the Soldiers' Monument in the cemetery to remove the time capsule likely included when the obelisk was dedicated in 1852. The capsule, Gianotti believes, may provide detailed information on how and where the men were buried.

But mostly, the people coming to Milford Cemetery are hobbyists making grave rubbings to collect epitaphs, genealogists and descendants of the dead.

The 1792 Molly Stone is probably the most photographed. The inscription reads: "Molly tho pleasant in her day Was suddenly seiz'd and sent away How soon she's ripe how soon she's rott'n Sent to her grave and soon forgott'n." The irony, of course, is that nearly 220 years later, she is anything but forgotten. Contrast the sentiments of Mary (Molly) Fowler's

bereft parents with this gentleman's: "Here lies my wife; don't forget her." Maybe if he told us her name she'd be easier to remember.

Other sentiments lend themselves to speculation, like the one lamenting the "ills of the big city" on the gravestone of a young man who died early in the twenteith century. It is difficult to separate fact from folklore, though the young man's parents may be excused for not anticipating that in their grief.

The earliest Milford settlers did not have any grave markers; as Puritans, they would have considered such things vain. The first burials were in unmarked plots in the Reverend Peter Prudden's garden, at the edge of the present cemetery. The oldest grave in the cemetery itself dates to 1689, fifty years after Milford's founding. William Roberts lies there, at the edge of a large open expanse at the center of the burial ground. Was the area left open for a reason, or does it contain unmarked graves? Officials aren't sure.

## HENRY A. TAYLOR AND HIS FAMILY

Henry Augustus Taylor was a generous man, and he apparently didn't mind if people knew it. Among the city buildings he named for himself and his family are the Mary Taylor Methodist Church, named for his wife, and Lauralton Hall, the name Taylor gave his High Street mansion in honor of his daughter Laura.

He also provided Milford with its first library building. The former Taylor Library at 5 Broad Street is now the offices of the Milford Chamber of Commerce. His 1895 gift required the town to provide the site and to agree to maintain the building. Town fathers were quick to grasp the opportunity, purchasing the land for $3,400. Taylor spent $25,000 on the ornate Romanesque building itself. The Taylor Library, on the National Register of Historic Places, was nearly lost in the late 1950s when a gas station was proposed for the busy downtown corner. The nascent preservationist movement in town, stung over the sudden loss in 1950 of the Clark Tavern, where George Washington famously dined, mobilized to save the library.

Taylor earned a sizeable nineteenth-century fortune in banking, railroads and real estate. The fields were sometimes linked, as speculators who bought up land where the tracks were to go could sell at a good profit. But the New Yorker is known best in his adopted town for his philanthropy.

The library and the church both have specially commissioned and beautiful stained-glass windows. Taylor family members—though not Henry himself—are depicted on the Methodist church windows. Henry Taylor had

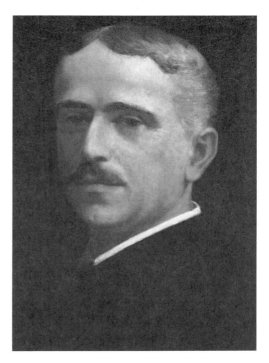

This portrait of Henry A. Taylor hangs in the chamber of commerce building, once the Taylor Library. *Courtesy of the City of Milford.*

thirteen children with his two wives, though Laura was clearly his favorite. Mary was his first wife, and the businessman donated the land for the church in her memory and paid for its construction in 1893.

Although the library building is in the style of famed Victorian architect H.H. Richardson, it was designed by New Haven architect Joseph Northrop. But a *New York Times* reporter was certainly impressed when he wrote about the Taylor Library's opening in the February 10, 1895 edition: "The historic town of Milford has become so fortunate as to be the possessor of one of the handsomest libraries in the state, through the munificence of a generous resident, Henry Augustus Taylor. The building is of a most attractive design and exceedingly picturesque from the outside is no less attractive on the inside, where comfort and convenience have been considered." The unsigned article goes on to describe the gifts of books by many residents, with families taking responsibility for lining each of the seven alcoves with books.

It took some legal wrangling to resolve the terms of Taylor's gift when city officials decided in 1976 that it was time for a new library. Finally, it was determined that as long as the city remained the owner and retained a civic use, Taylor's generosity would still be honored.

So the chamber of commerce moved in to the wood-paneled first floor, with the portrait of a young H.A. Taylor over the fireplace. Robert Gregory, the business organization's director at the time, had the original Tiffany windows reinstalled, and the large, ornate wooden table that generations of schoolchildren had done their homework on was given over to board meetings.

The Milford Fine Arts Council was ensconced on the second floor for nearly twenty years before the former eastbound train station was renovated for its use. In 2006, a persistent mold problem led to the sealing off of the basement and the installation of specialized airflow equipment.

## SYLVESTER Z. POLI AND HIS PALACES

Author F. Scott Fitzgerald famously said, "There are no second acts in American lives," but that clearly didn't apply to Milford-based show business impresario Sylvester Z. Poli.

Born in Tuscany, Italy, in 1858, Poli showed much early promise as a sculptor and went to France to study at thirteen. After brief military service and an apprenticeship, the young Poli began applying his artistic talents for a French museum. Contacts there won him an invitation to come to the United States in 1881.

Newly married, Poli moved from New York to Philadelphia in 1886, where he became the chief model-maker for the Egyptian Museum. That would have been a career for anyone else, but the ambitious artist saw a chance to take his works on tour and ultimately to open his own museum, in Toronto, to house them. Already showing Barnum-like flair as a showman, Poli displayed his wax figures on the third floor of the building, used the second for a menagerie—a small zoo—and used the main floor to stage live performances.

That was when the man found his niche and began earning the fortune that would pay for his fabulous Villa Rosa compound of shorefront "cottages" here, just outside of Woodmont.

Packaging a bill of vaudeville acts, arranging an evening's entertainment and sending the production out on tour made Poli a producer and a friend to the show business elite of the day.

Folksy comedian Will Rogers wrote home to his wife, Bettie, from Springfield, Massachusetts, in April 1908: "I am playing what is called here the 'Poli circuit.' He owns seven houses and I guess I will play them in rotation. I go on to Hartford next week."

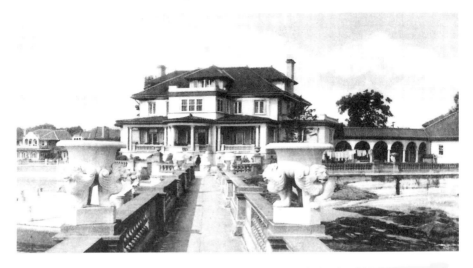

Sylvester Z. Poli's mansion, Villa Rosa, shortly after its completion in 1913. Many stars of film and vaudeville, including Harry Houdini and Will Rogers, were known to have visited. *Courtesy of Katherine Krauss Murphy.*

Rogers became a close friend of Poli and reportedly was one of the many stars who visited at Villa Rosa. The Milford theatre magnate continued to buy theatres through the 1920s, gradually shifting their programming to rely more on films than on live performances.

Magician and historian Dick Brooks of the Houdini Museum in Scranton, Pennsylvania, said that Poli and the famed escape artist were good friends and that it is likely that Harry Houdini visited Villa Rosa. Documents at the museum indicate that Poli only reluctantly switched his business over to movies, believing that live entertainment was more enriching to its audiences, even if it wasn't as profitable to him.

According to his obituary in *Theater Enterprises* magazine, Poli was among the first to include films in his programs, as early as 1891. Seeing the trend, Poli redesigned many of his theatres into opulent "palaces," with plush chairs, thick velvet curtains and drapes and lobbies decorated with frescoes, statues, fancy lamps and sconces.

He was known for "cleaning up" the sometimes bawdy stage shows, making them fit for women and children to attend. One of the features at his biggest theatres was a live orchestra, often billed as "Poli's Own Handpicked Orchestra," though chosen from among local musicians.

When Poli acquired his first theatre, on Church Street in New Haven in 1903, he hired a renowned architect to redesign the complex and add three hundred seats, writer Manny Strumpf said.

He opened his theatre in Waterbury to much fanfare in 1921; at the time, it was the largest building of its kind on the East Coast. It has slightly fewer seats than Radio City Music Hall, which was opened in New York City more than ten years later. The Waterbury Palace has been restored and extensively refurbished by a combination of city and state grants, and once again it is a venue for live stage shows. The Poli chain in its heyday also included the Park City Theater in Bridgeport and "houses" in Hartford, Springfield, Providence, Boston, Washington, D.C., Wilkes-Barre and Scranton, Pennsylvania, and Jersey City, New Jersey.

According to show business lore, Poli booked a young Al Jolson into the New Haven theatre as part of a singing group—and recommended to the cantor's son that he drop the others and go solo. Who knows? Neither man lacked ambition, and Jolson was not known for sharing the limelight with anybody.

When his son and heir died unexpectedly in 1928, Poli sold his theatre chain and retired, though he retained a mortgage on the buildings. The Great Depression forced the buyer into bankruptcy, and Poli briefly resumed his ownership until he sold the eighteen remaining theatres to the Loews chain for an estimated $20 million.

Milford throughout the Poli era—before the cineplexes with multiple screens and seats with cup holders—had many movie theatres. But of the Tower (opened in 1911 in Walnut Beach), the Colonial, the Capitol downtown and the many others, none was part of the Poli chain.

Strumpf wrote in his biography of the showman that Poli was honored by King Victor Emmanuel of Italy for his charity works, and President Franklin D. Roosevelt sent his personal congratulations to Sylvester and Rosa Poli on their fiftieth wedding anniversary in 1935. Two years later, Poli died of pneumonia at Villa Rosa. He is buried in an elaborate mausoleum in St. Lawrence Cemetery.

## HOME TO TARA...IN MILFORD?

According to some online sources, including Wikipedia and the usually reliable Internet Movie Database, some scenes of the 1939 epic of the antebellum South, *Gone With the Wind*, were filmed here in Milford, a picture-perfect New England town.

But the truth, as is often the case, is more complicated than that. There *is* a local connection to the classic film, but Clark Gable and Vivian Leigh as Rhett and Scarlet never set foot here. The Internet can function like a giant game of "telephone" at times, with rumors and sketchy facts growing bigger with each retelling. That seems to be what is at work here, film experts say.

An employee of the Academy of Motion Picture Arts and Sciences Library in Beverly Hills combed through voluminous news articles published around the time of the filming and premiere of *Gone With the Wind* and found no reference to Milford. Neither did the city get a mention in the indexes of several scholarly books on the film, the researcher said.

Steve Wilson, an archivist at the University of Texas, where *Gone With the Wind* producer David O. Selznik's personal papers are stored, said no scenes were filmed here. "No Tara, no burning of Atlanta, nothing; sorry," he said. So where did this erroneous report get started? Wilson said he has been contacted a few times over the years by Milford residents who apparently have heard the rumors about the connection and want to know more.

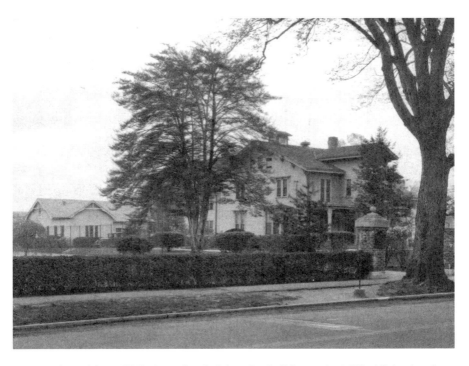

A 1930s view of Stern Hall, the main administration building at the Milford School and a possible inspiration for Scarlett O'Hara's home in *Gone With the Wind. From the Henry "Buster" Walsh postcard collection.*

"What I found is that it is probable that 'reference photos' were taken in Milford," the archivist said. "There were hundreds, maybe thousands of reference photos taken all over the country for this film, and [location scouts] would take them back and sets might be built from them, on sound stages or on the forty-acre MGM back lot."

The most recent call from Milford to Wilson's office in Austin was in the late 1990s. "It was someone from a private boys' school there wanting to know if their main building on campus was used in the film," the archivist said.

The white Victorian Stern Hall on the Milford Academy campus could look—in the right light—like a mini-Tara, or at least like Ashley Wilkes's home.

But do you give a damn?

# A 1948 "DOCUMENTARY"

A short film shot here in 1948 captures Milford in its last days as a farming community, an almost Mayberry-like small town. *A U.S. Community and Its Citizens* was shot on 16-mm black-and-white film and produced by Louis de Rochemont. It was part of his *March of Time* series that played in movie theatres before the feature film, said J. Dennis Robinson, a film historian and de Rochemont expert. The producer is credited with developing the "docudrama" and expanding the film noir style of cinema later in his career.

There are enough familiar scenes in the film that longtime residents can quickly recognize local landmarks. One of the opening scenes is at the old West Main Street School, which is an office building now. Some of the farming scenes were shot on Orange Avenue, near where Platt Technical School is now.

The narrative thread of the twenty-minute film is that students in a geography class are assigned to research and report on their hometown, with small groups of students covering different industries and aspects of Milford. A girl flies over the town in a helicopter, taking photos with her Brownie box camera, while two boys help a farmer bring in the hay and then "ride into town" in his pickup truck.

One of the students sees a small fire flare up and pulls the alarm box, summoning firefighters from the Point Beach Fire House. The men slide down the brass pole, step into their rubber boots and ride off to the staged fire in a hook-and-ladder truck, siren blaring.

Teens are shown hanging out at the soda fountain in the Milford Pharmacy, which once stood at 1 New Haven Avenue. Newsboys fold papers at the *Milford Citizen* office. The paper, then a weekly, was published in a building across from City Hall, where H. Mangels Confectioners is now. A police officer with a whistle in his mouth is shown standing in the intersection of River and Broad Streets directing traffic, without even the "bucket" that protected later cops.

As for de Rochemont, after his series of newsreels and war propaganda films, he moved on to features. His films, including *13 Rue de Madelaine* starring James Cagney, *Boomerang* starring Dana Andrews and *Lost Boundaries*, about a black family passing as white, have been shown on Turner Classic Movies. Film historian and critic James Agee has praised the producer-director's work for, among other things, its gritty realism. Some historians credit de Rochemont with being the first to shoot with 70-mm film, years after his Milford project. Robinson, the producer's biographer, said de Rochemont cast Ernest Borgnine in his first role and discovered Warren Beatty.

## THE IRON HORSE'S "MAMA"

Christina Gehrig, like her famous son, would rather have her actions speak for her than any words. So when she moved here in the late 1940s after her husband's death, she generally kept a low profile. But the mother of New York Yankee great Lou Gehrig helped dedicate a baseball diamond on Meadowside Road in memory of her son, where generations of Milford children dream of being the next Yankee first baseman. Mark Texeira and Don Mattingly are among the notables who have played the position since, but baseball fans will always remember Gehrig for his prodigious hitting and for his grace and class—traits not always associated with the Yankees.

"Mama" Gehrig enjoyed attending games in the youth baseball league named for her son until her own death in 1954. A plaque on the field's concession stand recalls her generosity and boosterism.

But few in town recall Mama herself; it has been more than fifty-five years since she passed away. Christina is portrayed in the highly fictionalized movie account of her son's life as a domineering, even overbearing woman. But Gehrig biographer Jonathan Eig suggests that had more to do with the feud between Christina and her son's wife Eleanor—and the fact that Eleanor was working with the film's producers—than any real traits. Rather than as the George Steinbrenner of her day, the baseball star's mother is remembered here as a warm, caring person who wanted to help local children.

Former recreation director Charles Schneider owns Gehrig's 1933 contract; it used to hang in Schneider's office. It was signed on March 10, 1933, and it says that Henry Louis Gehrig of New Rochelle, New York, shall be paid the aggregate sum of $23,000. The contract is on a form issued by the League of Professional Baseball Clubs Inc.

When the National and American Little Leagues here voted to merge several years ago, they chose as a new name the National Lou Gehrig Little League to honor the city's connection to the player who was known as the "Iron Horse."

Gehrig played in 2,130 consecutive games, a record only broken in 2002 by Cal Ripken Jr. But the Yankee Hall of Famer is still the only player to score one hundred runs and drive in one hundred runs in thirteen consecutive seasons. The Yankee great died in 1941 from amyotrophic lateral sclerosis (ALS), a fatal muscle-wasting disease that now carries his name.

The statewide chapter of the ALS Association is based here, giving Milford yet another connection to Gehrig. The association marked the 100th anniversary of his birth in 2003 by displaying a fifteen- by twenty-foot replica of the Yankee great's jersey at the Milford Oyster Festival.

## BILL CLINTON SLEPT HERE

The jury is still out on former President Bill Clinton, whose presidency was marked by unprecedented economic expansion and marred by sex and influence scandals. But however Milford residents may feel about the man himself, Clinton's time spent in a rented house at Silver Sands Beach gives him a local connection.

And Clinton, by all accounts, enjoyed his time living here as a first-year Yale Law School student in 1970–71. Maybe it was because he met his future wife Hillary, now the U.S. secretary of state, that year, but the former president has clear memories of his local sojourn. On at least two occasions when the former president attended fundraisers with Milford residents, he made a point of mentioning his "beach house."

"He said, 'You're from Milford? I love Milford,'" recalled former state legislator James Amann. Clinton recalled his exact local address and remembered that he liked to frequent the now-defunct Pilgrim Barbeque restaurant in the neighborhood, Amann said. The former president also recalled playing touch football on Fort Trumbull Beach and buying ice cream almost daily from Ron Dunphy, then an enterprising teenager and later a city Department of Public Works employee.

"He lived at 889 East Broadway, and I grew up a block away," Amann said. "I probably passed Bill Clinton a thousand times. We called Clinton's part of East Broadway 'Keg Row,' because of the college kids and their parties," the local man said. Clinton lived in the house with Yale classmates Donald Pogue and Bill Coleman and Oxford University friend Doug Eakeley.

In his 2004 memoir *My Life*, Clinton wrote that soon after his arrival in Connecticut he began working as an organizer in Joe Duffey's primary campaign against U.S. senator Thomas J. Dodd, who was seeking reelection. Duffey won the primary but lost the election to Republican Lowell P. Weicker when Dodd ran as an independent. Clinton recalls driving his battered, rust-colored Opel station wagon daily between Milford and New Haven. He and Eakeley had found "a great old house right on Long island Sound, with four bedrooms, a large kitchen and a screened-in porch that opened right onto the beach. The only drawback to the place was that it was a summer house, with no insulation against the whipping winter winds."

President Clinton writes about Hillary's visits to the house at Silver Sands, even recounting the first meeting between his future wife and his very protective mother, right on East Broadway. Hillary had cut her own hair the day before, and "with no makeup, a work shirt and jeans and bare feet coated with tar from walking on the Milford beach, she might as well have been a space alien." Clinton's mother decided that the future first lady and secretary of state "had no apparent style," and it took the two strong-willed women a while to warm up to each other.

## OFFICER DANIEL S. WASSON

When he was killed in the line of duty on April 12, 1987, Officer Daniel Scott Wasson, twenty-five, had already received three commendations for outstanding service in just two years with the Milford police. A U.S. Air Force veteran, he was engaged to be married and had already been promoted once. But during a routine motor vehicle stop on a Sunday, Wasson was killed by a single shot in the chest from a .44-caliber handgun.

The officer and his police dog partner, General, had pulled a car over on Boston Post Road near the Orange town line. When he walked up to the vehicle, Wasson was fatally shot by Thomas A. Hoyeson, formerly of Bridgeport. Hoyeson was caught in Bridgeport a short time later and eventually pleaded guilty to capital murder charges. His lawyers avoided a death sentence for the defendant by establishing a mitigating factor: Hoyeson

was mentally impaired when he murdered Wasson because he'd been on a three-day cocaine binge. General was retired from service and cared for by the officer's family.

Although no clear motive for shooting the Milford officer was established, the trial transcript described Hoyeson as "in a paranoid state, highly agitated, [and] highly fearful" when Wasson pulled him over. He is serving a life sentence without the possibility of parole.

While the killer's name is deservedly obscure, Wasson's is commemorated in Milford, the city he served, in several visible ways. The state legislature, at the urging of Senator Winthrop S. Smith Jr. and Representative James A. Amann, agreed to rename the Milford parkway feeder the Daniel S. Wasson Connector in June 2003. The busy stretch of highway allows motorists to access Interstate 95, the Merritt Parkway southbound toward New York City and the Wilbur Cross Parkway northbound toward Hartford. The renaming ceremony was attended by police K-9 units from around the state, as well as members of Wasson's family, who still live in Milford.

The Daniel S. Wasson Field behind the Parsons Government Center downtown hosts youth baseball and softball leagues, soccer games, Scout campouts and pickup games.

And at Milford Police Headquarters on the Boston Post Road, the slain officer is listed on a granite memorial in front of the building, and his portrait hangs behind the main service window. Wasson's badge number, 60, was retired and his locker, 43, remains empty in tribute.

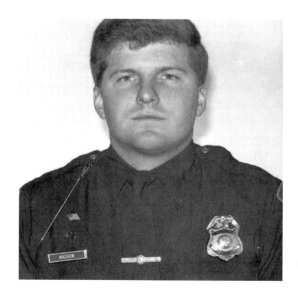

Officer Daniel Scott Wasson.
*Courtesy of the City of Milford.*

When the department officially marked the twentieth anniversary of Wasson's death in 2007, Sergeant Vaughan Dumas, the department spokesman at the time, said, "We promised never to forget Danny, and we are keeping that promise."

## MARGARET EGAN

Many politicians would envy the record of Margaret Egan, the city clerk from 1959 to 1961 and 1963 until 1987, when she retired. Running unopposed in nearly all of her thirteen election campaigns, Egan lost only once, to Kent Newton in 1961, when the Milford Independent Party supporting Charles Iovino won the election.

But Egan, who spent more than half of her ninety-two years in Milford, was much more than just a dedicated public servant. She served as chairwoman of the United Way, volunteered at Milford Hospital and for several local charities and, according to her friends, played a mean game of bridge.

A newspaper reporter in Massachusetts before moving to Milford, Egan operated a travel agency here for many years before she entered politics. Mourners at her funeral in St. Mary's Church in June 1998 recalled her genuine warmth and kindness. The former Lennox Avenue School in Devon was renamed the Margaret Egan Community Center when she retired in 1987.

## THE CITY IS READY FOR ITS CLOSE-UP

When the cast and crew of the motion picture *Righteous Kill* rolled into town in 2007, they stirred up quite a bit of excitement. Streets were closed, autograph-seekers were kept at a respectful distance from stars Al Pacino and Robert DeNiro and extras lined up for a chance to be living scenery.

State tax incentives for film production in Connecticut had already brought several movie companies to the area, but this was Milford's first cameo. City resident James Amann had pushed for the tax credits as House Speaker, and he had taken to calling the state "Hollywood East."

Robert Gregory, the economic development director for the city, is the point person for production companies wanting to film here. If you look carefully—and you may have to freeze-frame the DVD—you can glimpse Gregory's sleeve and arm as he plays pool in the background of a scene at

the Star Café. That Devon bar was a pivotal setting in the story of a serial killer who only targeted people who "deserved killing," i.e., the ones who had somehow escaped justice.

During the several days of local shooting, Pacino in particular became a fan of the Italian food at Al Dente Restaurant. The actor had several entrées sent to his trailer and posed for a photo with owners Christina Darchangelo and Dan Bagley.

Before *Righteous Kill*, the only Hollywood connection Gregory could certify was hardly a starring role. "The people from *Amistad* called me and they looked at some locations and the harbor," he said. "But all they ended up using was some fish from Dave's Seafood. They packed it in ice and took it to Mystic, where they were filming." The 1997 Steven Spielberg film recounting a slave ship rebellion and the slaves' legal battle to win their freedom was set in New Haven.

Four other movies listed as being filmed partly in Milford apparently were, though none has the cachet of *Gone With the Wind*. The 1996 Sylvester Stallone thriller *Daylight*, about the collapse of a New York City traffic tunnel, shot some exteriors at the Devon power station.

And *Save the Forest*, an independent film about the closing of a neighborhood movie theatre, was shot on Gulf Beach, in the Parsons Government Center and in private homes here in 2003, director Mike Field said.

In 1974, *Man on a Swing* featured Joel Grey, fresh from his Academy Award for best actor in *Cabaret*, in scenes filmed at the Connecticut Post Mall. In one scene, Gray runs from the mall—much smaller at that time— to the Ryder Mobile Home Park a block away. Except for that glimpse of Milford thirty-five years ago, there appears to be little reason to view this movie. Grey played a psychic helping a police chief played by Cliff Robertson to solve a murder, according to the Internet Movie Database. The film is available on DVD.

Much earlier, an R-rated adaptation of Voltaire's *Candide* began with a scene of the downtown duck pond. The credits were still flashing when Milford's appearance was over, and none of the star-studded cast came to town. That 1968 film, *Candy*, was greeted as the soft-porn of its day, with the advertising tagline: "Everybody loves Candy." Richard Burton, Marlon Brando, John Huston, Walter Matthau and James Coburn appear in the film, which is also available on DVD.

Chapter 7

# KEEPING THE FAITH

## St. Mary's and the "Mission" Churches

The influx of Irish Roman Catholics into Connecticut in the mid-nineteenth century led first to the creation of St. Mary's Church in New Haven and then, a few years later, a satellite church with the same name here. Now in its third building, the parish is the mother church for the city's Roman Catholics. Other parishes here, including St. Agnes in Woodmont and St. Gabriel in Walnut Beach, began as "missions" from St. Mary's to serve the influx of summer residents in those neighborhoods.

The "old" St. Mary's Church, actually the parish's second sanctuary, stood at the corner of Gulf Street and New Haven Avenue from 1882 until it was destroyed by fire in the early 1950s. The rectory and the parish hall were across the street, where a gas station is now; Olympic Doughnuts is now where the church was.

Irish immigrants fleeing the potato famine and seeking work on the railroad began settling here in the 1850s, historian DeForest Smith wrote in his book *Only in Milford*. At first, local Catholics celebrated Mass in their homes with a visiting priest or traveled to New Haven for Sunday Mass before the first St. Mary's Church was built on Gulf Street.

Besides the mission churches, two other parishes were carved out of St. Mary's when enrollment there grew too large. St. Ann in Devon and Christ the Redeemer in north Milford were created in that way, Christ the Redeemer most recently, in the late 1970s.

When St. Mary's marked the fiftieth anniversary of its current sanctuary in 2005, one of the highlights was the replacement of its original pipe organ.

That instrument was dismantled in 1985, but several of its wooden pipes, ranging in size from eight inches to four feet, have been integrated into the new organ installed by craftsmen from Casavant Freres, a St.-Hyacinthe, Quebec company. The church's choir loft and gallery had to be enlarged to accommodate the $560,000 organ.

# A TALE OF TWO SYNAGOGUES

Recent years have seen a wonderful restoration and expansion of Judaism here, with a full-time rabbi installed at what had been the oldest summer-only house of worship in the Northeast and the relocation of a vibrant, growing Conservative congregation from West Haven.

Rabbi Schneur Z. Wilhelm relocated to Milford from Brooklyn in 2007 and now heads the Hebrew Congregation of Woodmont, an Orthodox synagogue that was established in 1926. The synagogue had been open only from July to September before that, to serve the spiritual needs of Jews from New York City, Massachusetts and elsewhere in Connecticut who spent summers at what they called "Bagel Beach." But although the building itself is on the National Register of Historic Places, the congregation had dwindled since the 1960s and was about to become history itself. Services had been led by the congregation, with a rabbi hired for high holy days, but at times there were not enough men to form a minyan, a quorum of ten required to hold services.

Rabbi Wilhelm, from Brooklyn, and his wife, or rebbetzin, Chanie, who grew up in Orange, have reinvigorated the faith community. Both still in their twenties, the young couple has held services in their home and started the Chabad Jewish Center of Milford, which offers instruction and programs for women and youth. The center maintains a website, www.jewishmilford. com, and has drawn as many as 150 worshippers to temple and many young people to shul, or Hebrew school, for instruction. Rabbi Wilhelm also serves on the city's Ethics Board.

The Wilhelms are part of the Chabad-Lubavitch movement of the faith, which requires strict adherence to Judaic laws. Men and women sit apart at the weekly Shabbat service, following Orthodox practice. The congregation, and its attached social hall at 15 Edgefield Avenue, is also a piece of Jewish American history, a vestige of the days when Woodmont was a summer colony and anti-Semitism stained the American character.

Dr. David Fischer, a noted oncologist who has written a history of the

area's Jewish population, said that the Woodmont neighborhood was more welcoming, but there was a less benign motive at work too. "The first Jews here, it was kind of like block-busting," he said. "They'd find these small cottages no one seemed to want, buy them up and tell their friends and family. Soon Jews from Waterbury and Meriden, Wallingford and Woodbridge were moving into Woodmont."

The same year that the Wilhelms arrived in Milford, Rabbi Dana Bogatz and Congregation Sinai relocated from West Haven to a new space at 55 Old Gate Lane. The Conservative congregation, founded in 1929, also maintains an active calendar of events and a growing Hebrew school under the spiritual leadership of Rabbi Bogatz. Members serve the greater Milford area with several charitable programs, including an annual toy drive. Congregation Sinai's website is at www.congsinai.com.

## The First Church to the United Church of Christ

The First Congregational Church here has been well served throughout its long history, with Prudden being followed after an interlude of four years by the Reverend Roger Newton and then by one of its longest-serving pastors, the Reverend Samuel Andrew, from 1685 until 1738. Church records show that the Reverend Bezaleel Pinneo, who also served fifty-three years, from 1796 until 1849, baptized 1,204 people and presided over the burials of 1,126.

One of Pinneo's largest contributions may have been the education he provided to younger ministers and candidates for the clergy, including some who went on to become the major voices in the Second Great Awakening. Among those was Asahel Nettleton, a contemporary of Lyman Beecher of Litchfield. The causes these men preached from the pulpit, including abolition, temperance and reform of the treatment of the mentally ill, were to shape the second half of the nineteenth century.

The minister's grandson, Alfred W. Pinneo, said at the First Church 250th anniversary service that the family name had originally been DePino, which means "pine tree" in Italian. It was "quite indicative of his appearance, tall and erect, a pine from the New England forest," the minister's grandson said.

The Memorial Bridge over the Wepawaug River, along with its iconic watchtower, was built that year to mark the 250th anniversary. A special town meeting appropriated $3,000 to the project, and descendants of the

The second meetinghouse belonging to the First Congregational Church, in a 1700s woodcut. *From The Proceedings of the 250th Anniversary of the First Church of Milford, 1889.*

founding families contributed funds. The bridge, of granite blocks quarried in Branford, was dedicated in August 1889, in time for the actual anniversary.

But the church here had seen some turmoil, too. By the time of the 250th anniversary, the Reverend Frank Ferguson noted, the Plymouth Church, the Second Congregational Church, had already served five generations of families after splitting off. In 1736, when Andrew was eighty years old, church elders wanted to call a suitable minister to assist him, but the leading candidate was deemed "not an evangelical" by many in the congregation.

Samuel Whittelsey Jr., the son of a minister in Wallingford and himself a Yale graduate, was accused of not preaching the Gospel but rather "a system of morals" that led to the expectation of a universal redemption for all believers. Although this is contemporary mainline Christian teaching, at the time it was quite radical, and fisticuffs supposedly broke out during the three days of debate over Whittelsey's ordination. After he won the endorsement of several leading men in the congregation, including Jonathan Law, Whittelsey was called to assist Andrew.

But the Calvinists among the congregation were not pleased with what they saw as the new pastor's unorthodoxy when he took over upon Andrew's death two years later. The group broke away and announced its intention to form a new faith community under the Connecticut Toleration Act, passed

in 1708. There were forty members at the first service of what became known as the Second Society, in November 1741, but visiting ministers invited to preach to the new group found themselves barred from the pulpit of the First Church.

Matters came to a head a few years later when Governor Law ordered the arrest of a lay preacher from Simsbury who had come to Milford to lead a worship service for the Second Society. The crime Benajah Case was accused of was "an act for preventing disorders in the public worship of God," a law that, while still on the books, had logically been superseded by the Toleration Act passed more than thirty-five years earlier. Still, the trial in the New Haven court took two days. Case argued that he was in complete accord with the Gospel and "the laws of Jesus Christ."

Law countered that the violation Case was being charged with was not related to Scripture, but statute: "Your business is to prove that the place where the meeting was attended was a lawful place for such meeting." The defendant was convicted and served a term in prison. Members of the breakaway congregation were forced to contribute to the support of the First Church until an act of the General Assembly released them in 1750.

The Plymouth Church, as the new congregation came to be known, called as its first permanent minister the Reverend Job Prudden, the great-grandson of Peter Prudden, thus coming, in a way, back to the beginning. But over time, the theological differences were smoothed out, so that by 1926, the First Church and the Plymouth Church across the river felt no desire to worship separately. The two congregations were merged, with the Plymouth building serving as a playhouse for theatre productions and program space for the combined church. First Church joined the newly formed United Church of Christ in 1961.

Other congregations serve Devon, Wildemere Beach and Woodmont; the Devon United Church of Christ celebrated its 100th anniversary in 2009.

## FAITH COMMUNITIES IN MILFORD

One of the earliest examples of interfaith cooperation, something that happens regularly today, was in 1823, when the Episcopal Church Society allowed First Church members to hold services in its sanctuary. The older congregation was building a new meetinghouse, its third, and the Episcopal Society, an offshoot of the Anglican Church of England, had already taken firm root here.

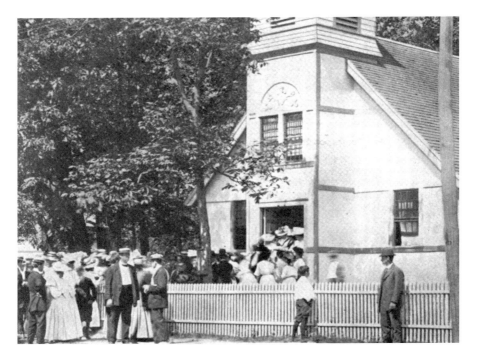

Worshippers at the Wildemere Beach Congregational Church, early twentieth century. *From the Henry "Buster" Walsh postcard collection.*

That was a busy period for church building in Milford. Besides the new First Church, the Plymouth Church, the Methodist Church in 1844 and the Baptist Church in 1845 brought nearly all of the mainline Protestant denominations into the town. Also during that period, the North Milford Ecclesiastical Society was formed; that society is now the Orange Congregational Church.

The Episcopal Society in its early days was plagued by financial difficulties; in 1803, the General Assembly granted it permission to raise $1,500 through a lottery. Organized here in 1764 as St. George's, the River Street church now known as St. Peter's was built in 1851 and expanded several times since, most recently in 1982. The city's second Episcopal church, St. Andrew's in Devon, was dedicated in 1954. But its history goes back much further, with services conducted in homes beginning in 1917. It became a "mission" church seven years later.

The first Methodist meetings were held in private homes and borrowed spaces from 1789 until its first church building was constructed in 1844.

For many years, Methodists here had no regular minister but were served by "circuit riders" visiting many towns on a set schedule. In between pastoral visits, members of the congregation would lead the service. The first Methodist church was dedicated in 1844 on River Street, and eight years later the local congregation got its first permanent pastor. Members of the Myrtle Beach Methodist Church combined with the congregation of the Mary Taylor Memorial in that downtown church in the 1960s, when redevelopment claimed their shorefront building.

Baptists here organized in 1831, fourteen years before members had a church of their own, but they began by meeting under the spiritual guidance of the Reverend J.E. Linsey of Stratford. There were about twenty-five members in those early years, but the Baptist congregation grew quickly after members purchased the old town hall for $150 and converted it into a church. Today there are two Baptist churches, including Milford's first "Negro" church, First Baptist, opened in 1891, an offshoot of the Emmanuel Baptist Church of New Haven. A second congregation, Grace Baptist, has its church on Burnt Plains Road.

The Fort Trumbull Beach Union Church began meeting in members' homes in 1920 and three years later purchased a former schoolhouse from the city to use for services. Nondenominational at first, the congregation joined the Presbytery of Southern New England in 1945 under the leadership of a young, newly ordained Presbyterian minister, the Reverend Dr. Robert Lamar.

As the Fort Trumbull Presbyterian Church, it moved into its own building in 1948, built by its members on Seaside Avenue. It became the United Presbyterian Church in 1961. A longtime pastor, the Reverend Daniel Hans, later moved to Gettysburg, Pennsylvania, where the church's current spiritual leader, the Reverend Anne Marie Meyerhoffer, worshiped as a girl. Meyerhoffer was installed in 2007 as the designated pastor and became the full-time, permanent pastor by a vote of the Session and the Presbytery two years later.

Trinity Lutheran Church, a congregation of the Evangelical Lutheran Church in America, grew out of meetings held in the Milford High School choir room in 1955. Its present building, on Robert Treat Parkway, was dedicated in 1973.

# Chapter 8

# TOWARD A MODERN CITY

## Milford Life in the Early 1800s

Municipal tax records dating back to the colonial era and business ledgers of merchants who conducted business here in the early nineteenth century indicate that taxes and the cost of everyday living were as much on people's minds then as they are now.

But in most ways, Milford was a very different place. Households bought an astounding amount of rum, cows and pigs were taxed as assets and official records listed which church a resident belonged to. And for several years after the United States won its independence from Great Britain, business transactions in Milford were still being conducted in pounds, shillings and pence.

Among the data in the 1770 grand list, meticulously recorded in what is now faded brown script, is the type of land owned—whether house lots, pasture or salt marsh—and the animals, including horses, cows and swine. The ages of the livestock are also listed. That year, a typical Milford farmer owned property worth 226 British pounds, 17 shillings and 6 pence. The value of everything in the colony was 28,924 pounds. There is no reliable way to convert that into today's value. The traditional rule is that each pound equals five U.S. dollars, but who knows what $5 would have been worth then?

A 1777 list of revenue collections includes what is likely the first local tax break: "an Abatement of the 20th part of the tax due in September." Among those receiving an abatement is Freelove Stow, widow of Stephen Stow, who died earlier that year tending to POWs critically ill with smallpox.

The widow's taxes that year were 13 pounds, 1 shilling and 6 pence, and the tax rate was a rather stiff 12 shillings per pound; there were 20 shillings to a pound.

The 1808 grand list was computed in dollars. But each entry lists whether a family belonged to the "First Church" or not. Despite the U.S. Constitution ratified in 1789 that demanded the separation of church and state, Milford continued to keep its public records along denominational lines until the Connecticut Constitution of 1818 expressly forbade the practice.

The document lists real estate and personal property; the value of all of the property in Milford that year was $54,639. That amount seems small enough, but even more so when one considers that Milford at that time comprised most of the Naugatuck Valley including Beacon Falls, Amity (present-day Woodbridge) and Orange (including what is now West Haven). The total amount on the 1808 list added "31 and one-half cents"; a half-cent was a common monetary measurement in that day.

Early maps of the Milford colony show it extending north in a narrow band along what is now Route 8. Present-day communities broke away at different times as their populations grew. It is likely that the mercantile store owned by Samuel and Ephraim Peck outfitted most of the households with their pots, pans, tools and sundries. The store—the Wal-Mart of its day—carried accounts for each family on its books and listed what they bought. The book, now owned by a private collector, has entries from 1801 to 1807. The exact location of the Milford business and the precise relationship between Samuel and Ephraim has been lost over time.

The Reverend Bezaleel Pinneo, pastor of the First Congregational Church from 1796 to 1849, bought several jugs of rum a year from the Pecks. It was likely for the minister's personal consumption, since wine and water would have been used in church services. It was an age when alcohol consumption, even by children, was high, especially in the cold weather months. Milford at the time was a shipping center, involved in the molasses and rum trade with the West Indies, so the stuff was plentiful and probably cheap.

The store also sold screws and nails to Andrew Durand—the joiner, or furniture maker, who was active at the time—seeds and animal feed to farmers and cloth and thread for making clothes.

By 1818, some Milford residents had become quite prosperous. Nathan Platt, for example, was taxed on property worth $80.34, including "five cows, 1 horse, 12 acres of pasture, three acres of bog and 10 acres of brush. Also a silver watch."

The Pond family's account in the ledger of Peck's General Store, prior to 1808. *Courtesy of Timothy Chaucer.*

Public schools here didn't really function consistently until the Board of Education was formed in 1875. Before that, "school societies" in different sections of the town received public funds to educate the children living there. School "visitors" would inspect the facilities and observe the learning going on, reporting back to the town government.

The first state law requiring taxes to pay for public education was passed in 1854. The rate that year, one-tenth of a cent for each dollar on the grand list, rose steadily, as might be expected. By 1866, it was four mills, or four-tenths of a cent per dollar—a rather shocking increase of 400 percent in just twelve years. A few years later, the state law was changed so that each community had to raise enough revenue to provide thirty weeks of schooling annually. Mandatory attendance was required beginning in 1872 for all children between the ages of eight and fourteen.

One oddity of the early education funding—because the money was kept separate from the town's general fund—is that Milford students and their parents sometimes received a "dividend." If the cost of their education that year was less than the money that had been collected to pay for it, students got that money back. Since at that time fees were still being charged to families sending students to the public school, the system was fair. But it is rather startling in light of the annual debate over education costs in Milford nowadays. The 1864 school fund had a surplus of $772.80, and each pupil received $2.25 as his or her share.

## Downtown at the Turn of the Century(s)

What a difference one hundred years makes. At the dawn of the twentieth century, the Green, then known as Milford Park, was enclosed with fencing that had been replaced around the New Haven Green, and sheep still occasionally grazed there. The Civil War Monument, erected by the Grand Army of the Republic, a veterans' group similar to today's American Legion, was one of the few permanent structures on the long expanse of grass.

Along the Green on both sides of Broad Street, houses were still more common than businesses. The Daughters of the American Revolution chapter house stood where the Milford Bank is now; the Henry Taylor Library had opened on the corner a few years before.

Harrison and Gould, a general store that sold guns, ammunitions and archery equipment until mid-century along with farm tools and hardware, wouldn't open for another seven years. Issie's Newsstand and the United

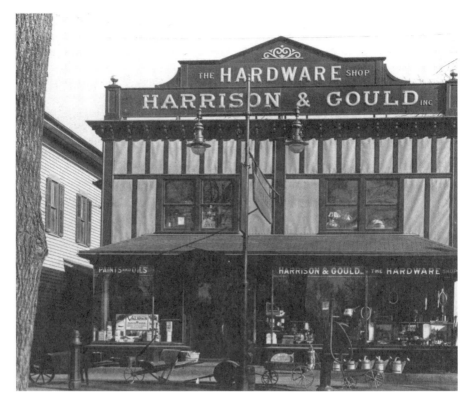

Harrison and Gould Hardware opened on Broad Street in 1907 and was a downtown fixture for nearly one hundred years. *From the Henry "Buster" Walsh postcard collection.*

Cigar Store were doing a brisk business on River Street, which was still used almost exclusively by horses. Farther up River Street, there was no post office or courthouse yet. City Hall—actually the town hall at that time—was a long, white wooden building. The distinctive "Doughboy" statue, a World War I memorial, was obviously not there yet; it is ubiquitous in almost all photos taken there after 1925.

The streets were not paved, and the Clark Tavern, then a private home, was still where the Parsons Government Center is now. Gracious homes like "Darina" stood where office buildings are now.

Change, once it came, happened quickly. By 1925, cars owned the downtown streets and automobile dealerships operated in the center of the city, on what was then U.S. Route 1, the Boston Post Road. A Packard dealership owned by the Rogers family commanded the corner of New

Haven Avenue and Daniel Street; the family's auto body shop now occupies that space. By the 1930s, a tire shop was operating on River Street next to Donahoe's, a candy and sundry store. Motorists pulled around to the back of the building; the garage bays were later enclosed and used for small shops.

Although its impact wasn't immediately felt, the 1932 decision to relocate Route 1 north of downtown began its decline as a retail center. At first what is now one of the busiest commercial corridors in the region was known as U.S. Route 1A and was called "The Cutoff" by local residents. Broad Street later became a section of state Route 162, the "lower route" to New Haven, in place in George Washington's day and known locally as New Haven Avenue.

For the next thirty years, families still did most of their shopping downtown. There were butchers and bakers—no one recalls a candlestick maker—and not only did Milford Center have everything, it had two of everything.

Mike Petrucelli, who owned the Town Squire Men's Shop for thirty years and the Milford Sports Shop before that, can still count the stores on River Street in the early 1950s. There were two newsstands, four barbershops, two shoe repair shops, four liquor stores, three pharmacies, three bakeries, three groceries and four businesses Petrucelli termed "department stores," although they'd be dwarfed by nearly any big box store today.

There were also three bars, including Jake's, the Office (so named, according to local lore, so that men could tell their wives they were going to "the office" and not be lying) and the Milford Men's Club. One store sold only fine ladies' hats, back when ladies wore hats, and two sold jewelry and watches. There were four men's clothing stores, five women's dress shops, a camera store, a fish market and two luncheonettes.

A police officer stood in a protective barrier, the famous "cop in a bucket," to direct traffic through the complex intersection where Factory Lane, River Street, Broad Street and New Haven Avenue all converged. The raised platform made the officer more visible to motorists; a heater warmed his feet in winter, and an awning shielded him from the sun. The bucket wasn't replaced by a traffic signal until 1971.

A pattern that was later repeated in small cities all across the country got an early start in Milford. Suburban sprawl led people to shop along major arterial routes, like the Boston Post Road, rather than wend their way through winding, narrow streets to downtown. There were hardly any houses north of the Wilbur Cross Parkway here in 1960, but now the neighborhood has several large subdivisions and its own zip code. That led many stores, restaurants and service businesses to relocate along the Boston Post Road,

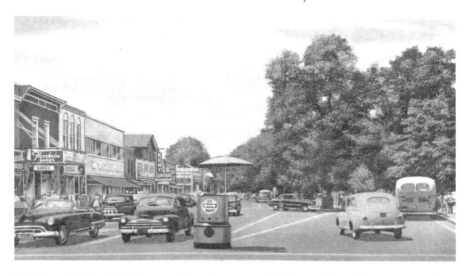

The "cop in the bucket" directs traffic at the corner of River and Broad Streets, 1950s. *From the Henry "Buster" Walsh postcard collection.*

Bridgeport Avenue and New Haven Avenue, leaving Milford Center empty and quiet, for a time.

The nadir for downtown was the late 1980s recession along with the savings bank collapse. A developer had nearly completed the retail and office complex at 1 New Haven Avenue when he lost it in a foreclosure. The building was a boarded-up eyesore for several years. Low, rambling factory buildings and an off-line sewage treatment plant bordered the harbor, which was served by a few private marinas.

A decade later, a new group of entrepreneurs was ready to help downtown shake off its slumber. Small boutiques selling unique items and new restaurants that drew "foodies" from as far away as New York began the revival. A study by the Yale University Urban Studies program detailed how off-street parking and more residential units could make downtown into a hip, trendy destination.

It had worked in other, larger cities, including New Haven, Baltimore and Providence, and in time it began to work here. The city, under Mayor Frederick L. Lisman, replaced the sewage treatment plant with a public marina and park. Developers Robert Smith and Philip Craft tore down the factory and built two apartment complexes with shops and restaurants on the street level. Retailers took back many of the spaces that had been used by lawyers, real estate offices and other service businesses that don't draw window shoppers.

The office and retail building at 1 New Haven Avenue was foreclosed on in the late 1980s recession, before it was competed. *Courtesy of the* Connecticut Post *newspaper.*

Downtown merchants organized events like Captain Kidd Day and the Lamplight Holiday Stroll that attracted families to the many shops. Free outdoor movies, weekend arts and crafts fairs, the annual Milford Oyster Festival and many other events make Milford Center a busy place from April through September. And in early morning and late afternoon, commuters dash across busy streets cradling coffee cups, newspapers and briefcases. A section of Daniel Street and New Haven Avenue is lined with bars and nightclubs that draw young singles.

There is a lot of activity downtown now, just as there was one hundred years ago.

## FARMING AND THE SEEDS OF DEVELOPMENT

Reminders of Milford's agricultural past are easy to find; present-day farms are a bit harder. There are graceful old barns at the edge of downtown and tucked away in neighborhoods with names like Orchard Hills and on now-busy streets like Wheelers Farm Road.

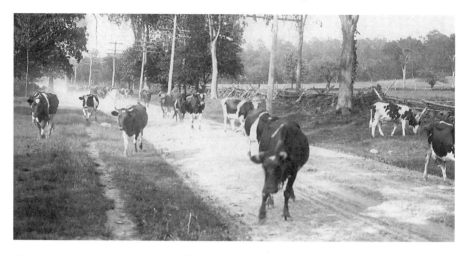

Cows meander along a dirt road in Woodmont early in the twentieth century. *Courtesy of Katherine Krauss Murphy.*

What is now the borough of Woodmont first appeared on local maps as Burwell Farms, a place where cows ambled down the narrow streets that bikes, skateboards and cars share now. The original purpose of the Green in Milford center was for a community pasture for sheep and cows. Animals grazed there throughout the nineteenth century.

Fruit orchards and dairy farms proliferated here at one time; the 1880 U.S. Census shows that most of the 3,347 Milford residents that year were somehow engaged in either farming or fishing. That was at the end of an era when most American families grew their own food. The Industrial Revolution brought more opportunities to make a living, and agriculture adopted some of the mass-production techniques first used in factories.

Maybe the first example of this in Milford was the birth of the modern shellfishing industry here. Always a staple of local diets, clams, crabs and oysters had been cooked and eaten by the people who had caught them. In 1878, the town had issued only forty-one commercial oystering permits, each for a two-acre tract on the Long Island Sound floor. Ten years later, William Merwin and Sons Co., the town's largest oystering firm, held permits for more than one thousand acres and reported a yearly yield of nearly one million bushels of bivalves.

One could say that the genetic engineering of food supplies got an important start here with the seed industry that sprouted, so to speak, in the mid-nineteenth century. By the time that industry faded into memory,

Seed bags and equipment from Milford farms. *Exhibit by the Milford Historical Society; photo by Nancy H. Juliano.*

more than one hundred years later, generations of Milford young people had stories of their first jobs crawling between rows of corn, onions or other crops, injecting various solutions into the plants' roots.

Everett B. Clark began the industry here in 1856 when he sold a crop of cabbage seeds he had cured and stored in the parlor of his home. When the American Seed Trade Association was organized in 1883, Clark was one of its founders. The business later became part of the Asgrow Seed Co., which owned the land that became Eisenhower Park and the Connecticut Post Mall.

Frank Woodruff, another seed grower, opened his own business about the same time, doing the billing and bookkeeping by lamplight at his dining room table. The Merwin Seed Farm operated for many years in the second half of the nineteenth century, before the land was sold to the developers of the Laurel Beach neighborhood.

With more families working off the homestead and moving into houses not surrounded by large tracts of land, commercial dairies began to serve their need for butter, cheese and milk. Milk from the Stowe Farm on Walnut Beach, the Platt Clover Farm and many others was delivered to homes several times a week in heavy glass bottles.

Hogs were raised and butchered here for many years; the Revolutionary War hero John Downs, a man of few words, noted several times in his diary that he "butchered the hogs today." Pork and bacon were staples in the local diet, and most residents at one time kept chickens for the eggs and meat they provided.

Some of the farm implements once used here are now part of the Milford Historical Society collections or are owned by private collectors. Municipal historian Richard N. Platt, the first in his family, he says, not to know how to harness a horse, has kept many of the tools from his family's orchard and farm.

The city historian's father gave up farming during the Depression to take a job with the U.S. Postal Service. Hog stretchers, sweat scrapers, hay rakes, oxen yokes, winnowing baskets and other tools that were commonly used on Milford farms are still retained here in private collections.

Farming has by no means disappeared in modern Milford. No fewer than ten agricultural businesses, from a bee keeper and riding stables to farms growing strawberries, flowers and shrubs, were listed in a 2008 brochure by the city's Open Space Committee. The committee applied for and received a state Farm Viability Grant that year to help the remaining agricultural businesses survive in an era of high land prices and huge food conglomerates.

One thing that has already come from that effort is a number of weekly farmers' markets, in several different neighborhoods, during the growing season. The people tending their plots in the Benson-Crump Community Gardens at Eisenhower Park have participated in the "Plant a Row" program that gets fresh vegetables to families on limited budgets.

Mary Treat hosts weekly farmers' markets at her Woodmont farm and also allows a seafood dealer and a butcher to come to the farm to sell their products. The Treat Farm grows and sells nursery plants and flowers as well as more than twenty kinds of vegetables, including tomatoes, corn and squash.

The Filanowski Farm on Wheelers Farms Road grows perennial and annual varieties of flowers, as well as trees and shrubs. Fawn Meadow Orchards grows peaches, apples and pumpkins, while Maple Tree Farm also raises figs, lemons and limes.

# Made in Milford: Straw Hats to Space Helmets

The first "product" of the Milford colony was beaver pelts, so many that the local Indians complained that the supply was being decimated. By then it hardly mattered because the settlers had cut down most of the trees, too, for shipbuilding, the next big industry. At the time of settlement, the harbor here was wider and the channel deeper, allowing for sizeable commercial vessels to weigh anchor.

The first merchants in Milford, Alexander Bryan and his son Richard, sold furs from animals trapped here to Bostonians and New Yorkers. The Bryans' credit and reputation were so high that for a time their handwritten IOUs were accepted as currency in Boston. The Bryans also built the first wharves and warehouses here to facilitate their trading with the West Indies, from where much of the colony's rum came. Later, they gave the wharves to the town for public use.

Not all of Milford's early business ventures were successful. Charles Deal received permission from the town to raise tobacco on Poquehaug (Charles) Island, but the crop did not thrive and the idea was abandoned. William Fowler, who was granted the right to own and operate the settlement's grinding mill in 1640, prospered by providing an essential service.

Henry Tomlinson obtained permission to operate the settlement's first inn, or "ordinary," but did such a poor job of it that his franchise was soon revoked. Historians recorded the problems with Tomlinson's inn: he managed to serve meals that were both meager and unappetizing, and he allowed young people to congregate and play cards.

The shipbuilding industry began at three sites: the east and west banks of the harbor in the center of the settlement, and on the Housatonic River. The first ship to be built and launched here, in 1690, was for the Bryans' trading business. The 150-ton brig was built by Bethuel Langstaff, who launched his second vessel five years later.

Until 1820, Milford's shipyards were bustling, building everything from small, sleek schooners and sloops to sturdy brigs—many of them commissioned by merchants from New York, Boston and Connecticut for use in the China trade or between European and American ports.

The only known vessel lost by a Milford merchant was Peter Pierett's, which sank in Long Island Sound while returning with its cargo of French wine in the early 1700s.

One of the early, distinctive Milford products were the "Heart and Crown" chairs made in the workshop of Andrew Durand. A century before

the gracefully curved and elaborately painted Hitchcock chairs came to represent Connecticut furniture making, Durand's short, squat, utilitarian chairs were fixtures in area homes. Using local hardwoods, the joiner would add a few distinctive flourishes of his own, including the "sausage turned" stretchers. The wooden bar on the front of the chair looks like a string of hot dogs—an extra, fanciful effort in an era when functionality was prized and powered equipment unavailable.

The Milford Historical Society owns three of the best remaining examples of Durand's sturdy, throne-like chairs. What is so special about these is not only that they were made here but that they stayed here, society official William Hoagland said. They were owned by one local family until they were donated to the society.

The chairs were made between 1750 and 1760, according to historical society records. The woven cane seat on two of the chairs is original; Durand, in the ethos of his day, built things to last. They only seem lower and smaller than chairs today because people are now larger, Hoagland said. The "Heart and Crown" design on the chair back was cut out of the wood and likely was a simple craftsman's response to the elegant carved chairs being brought from Europe during the same era.

While Milford furniture usually remained here, most of the town's other manufactured products were meant for export. They went all over the world aboard the sleek clipper ships that would call at Milford Harbor. Locks and brass fittings were among the items stamped "Made in Milford," most of them from factories clustered around the downtown harbor.

Starting in the 1850s, a series of brick and wooden factory buildings churned out goods for the country's emerging middle class. Those items included the whalebone stays that gave shape to women's corsets. The same factory produced stays for men's shirts, too, and was profitable until plastic buttons came along about one hundred years later.

Several local businesses mass-produced straw hats, which were a fashion rage for more than fifty years starting in the late nineteenth century. The last of the straw hat factories closed just after World War I. Many of the hats made here were sold down South, where the season for wearing them is longer. The Mitchell Company, which opened here in 1888, was particularly enterprising, making the hats and using the leftover straw for mattress stuffing. The Baldwin family operated the largest hat factory here, one that employed more than seven hundred workers in 1852, a large number even by current standards.

The Waterbury Lock Co., despite its name, made many other items, including tape measures and lighters. Its pipe lighter was designed to send

the flame downward, into the bowl of the pipe. Its Broad Street factory is now office space and residential condominiums.

A 1939 list of industries and the products they made here includes the brass and bronze andirons and candlesticks from the Rostand Co., the Henry Stuart Co.'s several types of "stays" for ladies' hosiery and girdles and carriage firms then making auto parts to adapt to the times. The A.J. Donahue Corp. was listed as one of only two earmuff factories in the United States that year. The company's two hundred employees produced about fifty thousand pairs of the ear warmers the year before and provided the winter accessory to 5-and-10-cent stores across the country. The company also made garters and hair curlers.

Of course, lighters, pens and disposable razors are the products that made Bic Corp. famous here. The company at one time employed one thousand people; most of its operations have been relocated out of Milford.

Schick Corp. completed an expansion of its Leighton Road facilities in 2008; the company's administrative offices are here too. Schick makes "shaving systems" with adjustable blades and lubricating strips that can last for years, with refills of course.

Fred DeLuca started the company that is now Doctor's Associates, the corporate parent of Subway Inc., in 1965 with one Bridgeport sandwich shop. The plan then was to raise enough money to finance his college education and to pay back Dr. Peter Buck, the family friend who had loaned him the seed money. Now, forty-five years later, the company (with its world headquarters here) is a leading franchiser, with thirty thousand restaurants in eighty-seven countries and more U.S. locations than McDonald's.

Milford also produces cutting-edge and high-tech products, from the Norden bombsights made here during World War II to the components for astronaut helmets made by the AirLock Corporation, an official vendor to NASA. Those iconic "bubble" helmets worn on the moon by the Apollo astronauts? Made by AirLock. Those specialized breathing masks designed to protect people during chemical and biological attacks? Made by AirLock. Components for life rafts, space walk suits and specialized sealed bearings and couplings? Yep.

Several metal fabricating companies here produce stampings, fittings and other components to incredibly precise tolerances. The Alinabal Group of companies, based here, has a worldwide market. PGP, Milford Fabricating Co. and others make the parts that make large, complex equipment work. Northeast Electronics is one of the few companies that specialize in glass-to-metal seals.

Jewelry makers Vincent Hutter, Susan Ashelford and Louise and Joseph Hebert can fashion new, trendy pieces out of all types of objects—one of Ashelford's designers makes bracelets from toothbrushes. Dyan Moore and Alison Grieveson, partners in GG2G Inc., make one-of-a-kind purses and handbags from recycled materials, including vinyl billboard posters. Their company name stands for "Green Goods to Give."

About the only thing that isn't made here these days is straw hats.

## Medical Care in Milford

Milford Hospital began in 1921 in what had become known as the Stockade House, a seventeenth-century saltbox that was the first to have been built outside of the colony's protective barrier. Besides the fledgling hospital's brief tenancy, the structure has also been a tearoom and a rooming house. The hospital had six patient beds and employed about as many nurses, a staffing ratio not possible in the current healthcare industry. The Beardsley family, benefactors of the hospital, donated the house and the land it stood on.

By 1923, a new building, the first on the hospital's present Bridgeport Avenue site, opened with 25 patient beds. The Stockade House was dismantled and the parts numbered; years later, it was reconstructed by the Milford Historical Society at its Wharf Lane complex. The new hospital had a small operating theatre and an "accident room," the beginning of what is now the emergency department. A new hospital building, opened in 1997 and oriented toward Seaside Avenue, won an architectural award for its design evoking a ship. It featured an all-new emergency care center, lobby and patient areas, operating rooms and outpatient surgery unit. In recent years, the hospital has added hospice and birthing suites, a cosmetic and aesthetic surgery center and a joint replacement and orthopedic center at Seaside Avenue and a Walk-In Urgent Care Center on the Boston Post Road. There are 150 patient beds, and the hospital is nationally accredited by the Joint Commission on the Accreditation of Healthcare Organizations.

There have been other healthcare facilities in Milford, including the Playridge Home for Crippled Children. Like Peck's Sanitarium for the treatment of "nervous disorders" and a tuberculosis hospital, that facility has disappeared with the changing times. All of these, not surprisingly, were located near the water so their patients could benefit from the sunshine, healthy air and cool breezes. A postcard of the Playridge Home

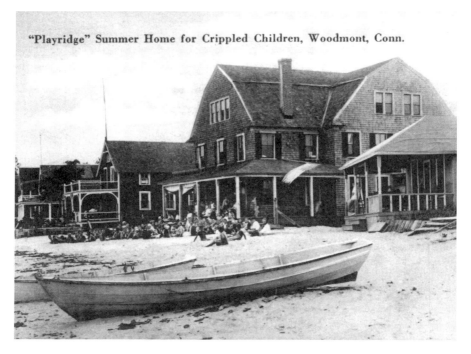

"Playridge" Summer Home for Crippled Children, Woodmont, Conn.

The Playridge Home for Crippled Children. *From the Henry "Buster" Walsh postcard collection.*

shows children playing in the sand. In the days when polio was a summer scourge, the camp-like program offered the children recreation, support and fellowship.

When Dr. Robert Peck opened his facility on Hawley Avenue in 1906, his first order of business was to clarify what types of patients would be treated there. It was to be a sanitarium, not an asylum, the doctor said, and "no mental cases will be admitted." Peck's was kind of a cross between a low-key resort and a hospital. Patients were encouraged to swim in nearby Long Island Sound, if they were able, or to shoot pool in the billiards room. But they were attended by nurses and a house physician, took meals in their rooms or in the communal dining room and had their visitors restricted.

A house rule required that patients be in bed, with the lights out, at 9:30 p.m. each night. An early fee schedule shows that patients, most of them being treated for what we would now call depression or anxiety, were charged weekly for their room and board and basic nursing care, but laundry services, extra nurses and meals for family members were billed separately.

## The Peck Sanatorium, Inc.

### General Information and Rates

Money, jewelry and other valuables should be deposited in the office and a receipt taken therefor. The Institution will not be responsible for articles when other disposition is made of them.

Patients desiring meal service for guests are requested to notify the office beforehand.

Breakfast is served at 8 A. M., to all patients in their rooms; Dinner at 1 P. M., and Supper at 6 P. M., in the dining-room.

Patients are requested to be in bed, with the lights out, at 9:30 P. M.

Any patient having cause for complaint of any sort will confer a favor upon the management by immediately notifying the Superintendent.

Patients are not allowed to visit other patients in their rooms except as a special privilege.

Smoking is not allowed in the house, except in the billiard-room.

### VISITORS

Patients may receive visitors during the hours of 3 and 6 P. M., subject to the physician's orders.

Not more than two visitors are permitted to see a patient at a time unless by special permission of the Physician in charge.

### CHARGES

Bills are due and payable one week in advance, and no patient will be received for a period of less than one week.

The fixed weekly charge for room and board include the general attention of the regular nursing staff, but not special nursing, special treatments, personal laundry, consultation, or medical attention other than by the Physician in charge.

Room and board are furnished to patients' relatives and friends for five dollars a week less than is charged patients. An extra charge of twenty-five cents is made for serving meals to patients in their rooms when able to go to dining-room. Single meals are served to patients' guests in the dining-room for Dinners, Weekday $.75 Sunday $1.00

Arrangements may be made with the Superintendent for personal laundry work.

### SPECIAL NURSES

The wages of special nurses vary from seven to twenty-five dollars per week, according to the grade of attendance required by the individual case, and are payable to the nurse, not to the Sanatorium.

A charge twelve dollars per week, ~~or one dollar and twenty-five cents~~ per day, is made for the board of a special nurse.

Rules and fees for patients at the Peck Sanitarium. *Courtesy of Katherine Krauss Murphy.*

Modern psychiatry—and modern prescription drugs—eliminated the role that facilities such as Peck's played in the healthcare system.

Milford also had one of the pioneering female psychiatrists, Dr. Helen Langner. She graduated from Yale Medical School in 1922 and opened her private practice in New York City, treating children. When Langner retired from that in 1970, she returned to her hometown, where she was granted privileges as an attending physician at Milford Hospital and saw patients privately.

The Peck Sanitarium, now a private residence in Woodmont. *Courtesy of Katherine Krauss Murphy*.

Langner, who lived until age 105, specialized here in treating older patients who had a fear of aging or dying, said Dr. Robert Kerin, a medical historian. It was a specialty that she would be particularly effective at, since the doctor herself led an active life right up until her final illness in 1997. Langner's life and career spanned virtually the entire twentieth century; she was the fourth woman to receive a Yale medical degree and had marched in suffragette rallies demanding her right to vote. She was twice featured in national media coverage on centenarians and their health secrets, though she noted, "If you live long enough you get recognition, whether you deserve it or not."

Langner was a common sight walking from her home on Shipyard Lane to her office at Milford Hospital, a distance of three-fourths of a mile, or to the city Department of Health. The doctor, who continued to see patients until she was ninety-eight, would not take a fee for her services, friends said. She would frequently attend events and programs at the Yale Medical School, riding the Connecticut Transit District bus from the center of Milford into New Haven. John Morris of the Yale Medical School said that Langner was due to receive a second degree from the school in 1998, a few months after her death.

# THE CONNECTICUT POST MALL

When the open-air Connecticut Post Shopping Center opened on a former onion seed farm on the Boston Post Road in 1962, it didn't look like the future of American retailing. It was an attractive center, built in an arcade style where shoppers exited one store and walked across a courtyard to another, similar to the layout now of outlet malls like Clinton Crossing. There were mostly family-owned businesses, not chain stores, and no "big box" retailers or anchor stores. That would come later.

But developer Sol Atlas and architect Jesse Hamblin were aware of the West Coast mall phenomenon; Hamblin designed a series of underground truck tunnels so vendors could deliver merchandise to the stores without blocking the large parking lots.

Within a few years, the Connecticut Post had its first anchor, Alexander's department store, and was the largest retailing center in the state. According to the International Council of Shopping Centers, an industry trade group, the first fully enclosed mall in America had opened in Minneapolis in 1956.

The "malling of America" era, when suburban shopping complexes sprang up almost as fast as the crops they replaced, really got going in the 1970s, when services such as hair salons, travel agencies, tax preparers and

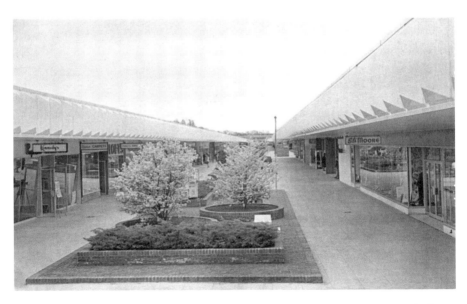

The Connecticut Post Shopping Center as it appeared in 1962. *Courtesy of the Westfield Group.*

other professionals began moving in alongside record stores (they were still called that then) and clothing shops. Food courts also became fixtures at about the same time.

At first, department stores owned the malls—Alexander's was the Connecticut Post's owner until the Australia-based Westfield Group bought it in 1991. By then, the growing number of stores had been enclosed by a skylight roof for ten years, with only a grocery store and the movie theatre outside the building.

Hamblin said that Westfield officials consulted with him on their plans to enclose the truck tunnels, turning the lower-level space into small retail shops. The architect said that it was a logical progression in the development of regional malls.

Alexander's, the store where most area residents bought their first suit or first formal dress, gave way to J.C. Penney in 1991. That same year, G. Fox Co. became another anchor; the store later became Filenes and is now Macy's. Sears was added in 1997.

Westfield spent $118 million to expand and upgrade the local mall in 2006. Several new stores were added, including Target, Borders and Dick's Sporting Goods, and a fourteen-screen cinema was built inside the complex itself. There is also a new food court. And in keeping with the idea of a mall as a destination, the new "village green," the local complex has wireless Internet access points—or hot spots—and a family lounge providing private nursing stations, bottle warmers and a microwave oven, along with toys and leather seating. A separate "Playtown" has whimsical characters, climbing elements, puzzles and floor mats for children.

The seventy-five-acre, 1.3-million-square-foot mall has 183 stores and about 2,500 employees. The $340-per-square-foot average sales makes it one of the most successful malls in the region. The Connecticut Post Mall is the city's largest taxpayer and its largest employer.

# THE 350ᵀᴴ ANNIVERSARY

In a way, the city's observance in 1989 of the 350th anniversary of its founding had begun seven years earlier with a flood. Heavy rains in April 1982 had sent the Wepawaug River, which flows behind city hall, cascading into the building's lower level. At the time, the basement contained the city clerk's office and records as well as several other municipal departments. The flooding was so bad that important documents were washed onto the

lawn of St. Peter's Church, a block away, caked in mud. Many records were destroyed, but some were salvaged by freezing them before the cleaning and preservation work could begin.

At that time, what is now the Parsons Government Center—to which most municipal departments were relocated—was still in use as Milford High School. So an already cramped City Hall got even tighter. File cabinets, desks and boxes of documents were set up in the aldermanic chambers. Employees from several departments worked out of that large room while books and papers rescued from the floodwaters dried out on the benches of the upstairs balcony.

Mayor James L. Richetelli Jr., a college student at that time, recalled the mess created by the flood. He said that the decision to close Milford High School and convert that space to offices was spurred by the water damage to City Hall.

Mayor Alberta Jagoe and her administration undertook the most extensive renovation of City Hall since the present building was constructed in 1916. The goal was to have the work completed in time for the 1989 celebration. Jagoe rededicated the newly refurbished City Hall as part of the 350th anniversary celebration "to all the people of Milford, to all of the

The aldermanic chambers of City Hall, used as makeshift offices after a 1982 flood. *Courtesy of the* Connecticut Post *newspaper.*

founding fathers who purchased [the land] in 1639 and to all of the citizens of Milford who lived in the city during those 350 years and who helped make our community a special place to live."

The mayor had wanted to put that first treaty, deeding over the original town site to the English settlers, on display for the occasion. However, it could not be found and is now believed to have been destroyed by a well-meaning but misguided archivist about 150 years earlier. "Alberta was absolutely crestfallen when I had to tell her it was missing," recalled Alan H. Jepson, who was serving as the city clerk at the time.

There were many other celebrations and pageants that year and some odd but fun events, including the "Brothers of the Brush," in which men competed to see who could grow the most impressive whiskers. Boys could join as honorary "little shavers." Women and girls had their own event, organizing into societies of "belles."

In a city that loves parades and holds at least four annually, the culmination of several that year was the official 350th anniversary procession. It reportedly took more than an hour to pass the reviewing stand.

A marcher plays the fife in the city's 350th anniversary parade in August 1989; the parade is reflected in his glasses. *Courtesy of the* Connecticut Post *newspaper.*

# Heyday for Jai Alai

There was a time, thirty or forty years ago, when Milford, not Foxwoods or the Mohegan Sun casinos, attracted the high rollers from New York City and the tri-state area. Cars would be lined up along the Exit 40 ramps of Interstate 95 on a Friday or Saturday night, waiting to descend into the gambling mecca that was the Milford Jai Alai fronton in its heyday.

It isn't even clear whether most bettors understood the intricacies of the Basque sport or were simply wagering based on the numbers or colors the players wore on their backs, and it also didn't seem to matter. Some people won a lot of money at the jai alai fronton, and nearly everyone had a good time.

During an era when there were no slot machines anywhere north of Atlantic City and fewer state lottery drawings, jai alai was literally the only game in town. Milford received as much as $200,000 a year in revenue as its share of the fronton's handle.

The beginning of the end for the state's three jai alai frontons—the others were in Bridgeport and Hartford—came when Governor Lowell P. Weicker reached an agreement with the two Indian casinos in 1991. The casinos got the exclusive right to have slot machines in exchange for a percentage of the revenue to the state. Within ten years, the high rollers were bypassing Milford for eastern Connecticut. A last-ditch attempt by the fronton's owners to add slots and table games got nowhere. When the facility closed at the end of 2002, there was talk of saving the architecturally interesting building, with its cantilevered decks. Some attempts to use it as a live entertainment venue didn't pan out, and the city purchased the twenty-five-acre property for $12.87 million to keep it on the tax rolls.

The Kingdom Life Christian Church was interested in the property, with its easy access to Interstate 95, to accommodate its growing congregation from all over the region. That last bet on jai alai placed by Mayor James L. Richetelli Jr. eventually paid off. A developer purchased the site from the city and built a Lowes Home Improvement store and a hotel there.

But the impact of the Basque game on Milford had been intense. A training facility and an amateur fronton opened elsewhere in the city, and soon American players were sharing the polished granite court with their Latin counterparts. The single-named players became mini-celebrities, sought out for autographs and to appear at community events. Cestas, the woven basket-like racquets used in jai alai, were sold in sporting goods stores. Hard rubber balls stood in for the hand-stitched goat hide pelotas used in official matches.

The state's Indian tribes were still running bingo games and selling untaxed cigarettes in the heady days when reservations were always required for the fronton's posh restaurant. Records from the counting room, behind an unmarked door off a hallway that was always guarded, show that on one day, November 21, 2001, the fronton took in $176,322 in cash. A few years earlier, the April 19, 1997 matinee brought in $25,000.

An apartment at the very top of the building had been occupied for twenty-five years by a man who was the "eyes and ears" of the place when it was closed, in exchange for free rent.

Out front, color-coded seats indicated the different levels, with the high rollers sitting down front in big, blue, padded armchairs. Attendants took bets and delivered drinks to patrons in their seats. A net stretched across the court protected people in the four thousand seats from an errant bounce—a pelota can travel more than 150 miles an hour.

City official Robert Gregory was one of the few residents invited to try his hand at the ancient game by fronton officials. "Jai alai is a lot harder than it looks," Gregory said. "It's more of a slinging motion. I tried throwing it and the ball just dribbled out."

Ironically, the state now permits the simulcasting of horse races, and the OTB parlor about a mile away from the jai alai site carries live races. Simulcasting races had been proposed by the fronton's owners as a way to stay in business, but state officials rejected the idea.

## THE CHICKEN LADY'S LAST STAND

Decades before a Connecticut eminent domain case reached the U.S. Supreme Court, a Milford woman became a folk hero by insisting that she be allowed to remain on land slated to become a state park.

Doris Gagnon was offered $15,000 for her small beach cottage on Silver Sands in 1971. When she refused it, the money was applied to her debts, including taxes and liens. The house was condemned and torn down, and city and state officials probably expected that would be the end of it.

Instead Gagnon moved into a small trailer, erected two small sheds alongside it for storage and set up camp. She lived there for the next twenty-three years, until her death in 1994. The New Hampshire native more than once evoked that state's twin mottos—"Live Free or Die" and "Don't Tread on Me"—in her frequent interviews with the media and the idle curious. "Silver Sands State Park" was just a plan in a file drawer in Hartford all

those years, as the woman raised chickens, fed stray cats and birds with stale bread and stubbornly remained in place.

It's not that she didn't face opposition from city and state officials; it was that she routinely won round after round of legal battles. The four-foot, eleven-inch, elderly Gagnon also drew a lot of public sympathy. Even though she had no legal address, the self-styled squatter received mail from all over the world. A letter from a woman from Georgia compared her to the Statue of Liberty, "another woman whose spirit cannot be dimmed." Gagnon had mail sent to friends' homes, and it also arrived addressed to her at "Silver Sands" or at the location where her house had stood.

When city police arrested her rather than investigate her cries for help, Gagnon won $14,000 in a lawsuit for unlawful arrest. That case reached the U.S. Court of Appeals in 1983, six years after the original incident. The federal judges ruled that a woman screaming because she believes someone is attempting to break into her home is not committing breach of peace, as the police officers charged.

Gagnon fought the attorney general's office over the state's persistent attempts to evict her and also battled breast cancer in her last years. A state

Doris Gagnon, the "Chicken Lady." *Courtesy of the Myrtle Beach–Walnut Beach Historical Association.*

official described the dilemma: letting the woman stay would mean that an individual can ignore a legal order, but evicting her would demonstrate a lack of compassion.

A 1989 settlement offer would have allowed Gagnon to remain in the newly created state park as an honorary "ranger." She scoffed at that and demanded instead that the state build her a new house to replace the one it had torn down.

During those years, the squatter would use propane tanks for heat, collect rainwater in buckets for her animals and shower at nearby friends' houses. Gagnon, long divorced, had no children and lived on her Social Security payments.

Within three years of her death, the long-delayed plan was carried out. A former municipal landfill behind the park was closed and capped, a road was relocated, six hundred feet of boardwalk was built and the marshes were restored. The park was officially dedicated in 1997 with no mention of Gagnon.

## THE BATTLE FOR RYDER PARK

To hear former residents talk about it, the old Ryder Park sounds like a cross between "Brigadoon" and the mythical "Shangri-La" depicted in the classic movie and novel *Lost Horizon*. Just like in those utopian worlds set apart, outside forces stumbled upon it and changed it forever. However, most area residents had thought for years that a mobile home park was an anachronism on the Boston Post Road, one of the busiest commercial corridors in the region.

Hidden behind a border of tall pines and its own white wooden newsstand was a twenty-five-acre park with narrow lanes lined by older, sagging trailers and large new mobile homes. Well-tended yards and gardens bordered each lot, and the enclave seemed almost defiantly frozen in time, ignoring the busy world rushing by just beyond its border.

When a new Super Stop and Shop with a pharmacy, bakery and movie rentals opened just behind Ryder Park in the mid-1990s, the grocery chain agreed to give park residents a gated footpath to come and go on their errands.

A survey crew entered the park in 1997 and began marking utility lines with orange paint, tipping off residents to what was about to happen. They called the local newspapers and hired a lawyer to fight the sale of Ryder Park to developers, touching off a nearly decade-long fight to remain where they were.

They ultimately had to move, but into a brand-new park that the association owns. The Milford Crossing Shopping Center anchored by a Wal-Mart has replaced the trailer park. It is harder to find anyone these days who is still singing the Joni Mitchell song about paving paradise—the current site off Cascade Boulevard has new manufactured homes, not house trailers, on wide, paved streets.

The main avenue through the new park is called McQuillen Drive for James McQuillen, the park resident who organized and led the legal battle. Residents voted to name the new park Ryder Woods, the last vestige of the "tourist camp" that Ralph and Ella Ryder had begun in 1932.

The Ryders bought the land just before the decision to make the street out front U.S. Route 1, relocating the main north–south highway from downtown. That meant that more travelers found their way to the camp than would have otherwise, and the Ryders offered cheap overnight accommodations in an era when long-distance auto travel was unusual and motels few.

A photo taken at Ryder Park in the depths of the Depression is part of a Smithsonian Institute exhibit called *America on the Move*. It shows a tired-looking mother and her daughter at a water spigot, filling their pail. The pair look like Dust Bowl refugees out of *The Grapes of Wrath* but more likely were headed to New York, where job prospects were better.

Right after World War II, several factors, including economic prosperity and improved roads, meant that there were more auto travelers and more hotels and motels to serve them. So the Ryders converted the campsite into a trailer park, leasing small lots that a trailer could be placed on either permanently or for short stays. Some utilities were also provided in the weekly and monthly fees. Except for the gradual shift from temporary to permanent residents, that's how the park remained for the next fifty years.

Lynn Nugent moved into Ryder Park in 1958, when she was eleven, and stayed after her marriage. Lynn and Larry Nugent were among the 180 remaining residents who left the original park for the new one two miles away in 2005. "I know people say the new place will be nice, and it'll be updated and all, but it won't be the same," she said before the move. "Before the legal wrangling began, some people didn't even know this place existed. It's quiet and nice here, and that's why we like it." The Nugents have since reestablished themselves at Ryder Woods, where Larry headed the residents' association during the process of buying the new park from the developer.

Rich Lenhard and Marian Clarkson moved into the old park a year before the decision to relocate it became final. "It's hard to say how we feel about moving," Lenhard said then. "We took a drive by the new place, but I don't

know if there is a plan for how it's going to be. I mean, is it going to be the same, with lots of trees and stuff? And will we have the same neighbors? We have kids and their friends live across the street from us here," he said. "What we like about it is that it feels like a real neighborhood back in here."

Every community event in 2004, from the July 4 picnic to Halloween trick or treating, was tinged with nostalgia as it was celebrated as "the last." The bitter fight began in 1997, when Westport developer Samuel Heyman purchased the forty-seven-acre property for $10 million from the estate of Ella B. Ryder. The couple's nephew, Gary Zink, was managing it when it was sold.

Attorney Beverly Streit-Kefalas, now Milford's probate judge, agreed to represent the residents in their fight to stave off eviction. A state statute giving mobile home park residents the right of first refusal when their park is sold gave the residents' association legal standing.

Heyman's group, Milford Holdings LLC, raised the monthly use and occupancy charges the residents paid while the court battle raged on. But the group also agreed to relocate the park, at its expense, to the new site, along with some cash compensation. Streit-Kefalas and co-attorney Charles Needle weighed several options and recommended that the association work with Trailer Funding LLC, a group representing Fairfield developer Louis Ceruzzi.

Besides covering the mounting legal bills, the Trailer Funding offer allowed residents the hope of staying on the property. All of the mobile homes would be moved to the rear twelve acres, and a smaller shopping center would be built along the Boston Post Road. During the four-party settlement talks, however, the most reasonable course to emerge was for the residents to move to the Cascade Boulevard site, which the Ceruzzi group purchased for them, and for the entire Ryder parcel to be developed as a retail center.

Just when things appeared to be resolved, eighteen rare Eastern box turtles were found on the Cascade Boulevard site, and work had to be halted. A state supreme court decision that blocks local inland wetlands agencies from basing decisions on the effects on wildlife alone finally allowed the new Ryder Woods to be built.

## How We Got Here

A study done in the mid-1950s predicted that Milford would have eighty thousand residents within the next thirty years. That never happened, but it

certainly must have seemed likely in the post–World War II housing boom. Orchards and fields were being plowed under for subdivisions, and schools were being built nearly every year.

Milford in the *Leave It to Beaver* era had neighborhoods whose names have long fallen into disuse. Do you know where Anderson Lawns was? It also had a Nike missile site during the cold war that later became housing for enlisted U.S. Coast Guard members serving in its Group Long Island Sound. The city could have become more like the larger neighbors that flank it—but it didn't.

Several key steps beginning in the late 1960s ultimately preserved Milford from the social ills, crime and blight that pervaded larger communities. The first was the gradual realization that shorefront property was valuable for year-round living. Whole neighborhoods that had emptied out after Labor Day began to have schoolchildren and church groups to enliven them. A switch from a partially appointed to an elected Planning and Zoning Board in 1982 brought more accountability to land-use planning.

That board's decision to restrict "cluster housing," in which large houses could be built on small lots surrounding shared open space, helped to limit density. A pair of decisions, one in the early 1990s to cap the height of residential buildings along the shore and another ten years later to measure that height in a uniform way, meant that Milford would never become Virginia Beach, Hilton Head or even Atlantic City.

An environmental movement that began with the 1970s Earth Day observances led to the creation of several groups: the Environmental Concerns Coalition, the city Tree Commission and Conservation Committee, Milford Trees Inc., the Milford Land Trust and the Open Space Steering Committee.

Letitia Malone, Timothy Chaucer, Ann Berman, John Dockendorff, Joan Politi, Kate Orrechio and Mary Ludwig were among the early proponents of land preservation and protection. The city now has an annual Freedom Lawn Contest, which awards the most beautiful landscaping achieved without chemical fertilizers or pesticides. All of the storm drains are marked with reminders that everything that enters eventually flows into Long Island Sound. Volunteers have counted every tree on public land in the city.

The 2004 Plan of Conservation and Development created special "village districts" downtown and in Devon to encourage pedestrians and create neighborhood centers. Regulations ban most neon signs, along with roof and lawn advertising larger than a certain size. More than 25 percent of the pork chop–shaped city is preserved as open space, and all but a few of its

seventeen miles of coastline is accessible to the public. There are probably more trees in Milford now than there have been at any time since the English settlers arrived—a tradeoff for the loss of farms. All of the historic structures here have been inventoried and new ordinances enacted to protect them. The Milford Historic Preservation Trust has begun a project to mark all the significant sites here. A second historic district has been created, and a third is being studied.

There is a delicate dance in which this community manages to both look forward and also back at its past. It has been going on for nearly 375 years with only an occasional misstep. Here's hoping that it continues.

# BIBLIOGRAPHY

## BOOKS

Acton, Jeanette, et al., eds. *Sand in Our Shoes*. N.p.: Myrtle Beach–Walnut Beach Historical Society, 2004.

Carroll, Chris, ed., Monica Foran, et al. *2009 Induction Ceremony*. Milford, CT: Milford Hall of Fame Committee, 2009.

Clinton, Bill. *My Life*. New York: Alfred A. Knopf, 2004.

Denno, Una, Letitia Malone, Harriet Racz, Cynthia Wolfe, contributing eds. *The History of a New England Hometown, 1639–1989*. Milford, CT: Milford's 350th Commemorative Book, 1989.

Dodge, Richard Irving, et al. *The Papers of Will Rogers: Wild West and Vaudeville 1904–1908*. Claremore: University of Oklahoma Press, 2000.

Dooling, Michael C. *Milford Lost and Found*. Middlebury, CT: Carrollton Press, 2009.

Eason, Peter. *The Founding Fathers' Footsteps*. Milford, CT: self-published, 2007.

Eig, Jonathan. *Luckiest Man: The Life and Death of Lou Gehrig*. New York: Simon and Schuster, 2005.

Federal Writers' Project of the Works Progress Administration, State of Connecticut. *History of Milford, Conn. 1639–1939.* Bridgeport, CT: Milford Tercentenary Committee, Braunworth and Co., 1939.

Ferguson, Rev. Frank L., ed. *Proceedings at the Celebration of the 250th Anniversary, First Church of Christ.* Ansonia, CT: Ansonia Evening Sentinel Press, and Cambridge, MA: Andover-Harvard Theological Library, 1890.

Kerin, Robert, MD. *Medicine in Milford: Memories and Myths.* Bloomington, IN: Author House Inc., 2004.

Lambert, Edward R. *History of the Colony of New Haven, Before and After the Union with Connecticut.* New Haven, CT: Hitchcock and Stafford, 1838.

Martin, Joseph Plumb, and George Scheer, ed. *Private Yankee Doodle.* New York: Little, Brown & Co., 2002.

Murphy, Katherine Krauss. *Woodmont on the Sound.* Charleston, SC: Arcadia Publishing Co., 2007.

Smith, Deforest W. *Only in Milford: An Illustrated History.* Milford, CT: George J. Smith and Son, 1989.

Sykes, Ruth Beach. *Memories of Ruth Frances Beach.* Woodmont, CT: self-published, 1995.

## DOCUMENTS

*Personal papers of George Coy.* SNET Collection, Thomas J. Dodd Research Center, Storrs, CT.

*Records of the Office of Governor, 1820–1858.* State Archives Record Group No. 005, Connecticut State Library, Hartford, CT.

*State v. Hoyeson.* Superior Court, Ansonia–Milford Judicial District, Docket No. CR 566329. Retrieved from www.jud.state.ct.us.

# PERIODICALS

Brockett, Rutheva Baldwin. "History of Milford." *Milford Historical Society* (1989).

Curtis, John. "Helen Langner: A Life of Engagement." *Yale Medicine* (Summer 1998).

Greenfield, Bruce. "Creating the Distance of Print: The Memoir of Peter Pond, Fur Trader." *Early American Literature* 37, no. 3. Dalhousie University, Halifax, Nova Scotia.

Holtz, Jeff. "At Historic Synagogue, a Congregation at Last." *New York Times.* December 9, 2007.

Juliano, Frank. "Milford mourns 'pioneer' Margaret Egan." *Connecticut Post.* June 11, 1998.

*New York Times.* "Ex-City Manager Becoming Mayor." November 8, 1959.

———. "Inventor Frank J. Sprague Urges Electricity for All Railroads." October 13, 1916.

———. "Milford's Handsome Library, the Gift of Henry A. Taylor." February 10, 1896.

Robinson, J. Dennis. "As I Please: Honoring the Father of the Docu-Drama." *Suncoast New Hampshire* 4, no. 13 (June 17, 2000).

Rosenthal, Larry. "The Immovable Doris Gagnon." *Ludington (N.H.) Daily News.* January 31, 1996.

*Waterbury Republican.* "Poli's Million-Dollar Palace Opens Its Bronze Doors Today." January 28, 1922.

Wolff, Craig. "She'll Stay Put, She Says, Park or No." *New York Times.* January 21, 1989.

# VIDEO

Arnold College alumni interview. *Memories* oral history project. Gerard Patton, Milford Rotary Club.

Celeste Lake interview. *Memories* oral history project. Gerard Patton, Milford Rotary Club.

Joseph Foran interview. *Memories* oral history project. Gerard Patton, Milford Rotary Club.

*Turn of the Century Milford*. Directed by Jamie Boss, narrated by Dick Galiette, 1997.

*A U.S. Community and Its Citizens*. Directed by Louis deRochemont, 1948.

# WEBSITES

Archived Papers of Frank J. Sprague. http://ieeeghn.org/wiki/index.php/Archives:Papers_of_Frank_Julian_Sprague.

Branford Electric Railway/Shoreline Trolley Museum. http://www.bera.org/collection.html.

"Eyes from the Deep: A History of U.S. Navy Submarine Periscopes." http://www.navy.mil/navydata/cno/n87/usw/issue_24/eyes.htm.

Frank J. Sprague biography. http://www.theelevatormuseum.org/e/e-1.htm.

Harry Houdini Museum. http://houdini.org.

James W. Schoff Civil War Collections at the University of Michigan. http://www.clements.umich.edu/Schoff.html.

Mace, Gordon. "Working for de Rochemont." http://www.in70mm.com/news/2003/de_rochemont/index.htm.

Smithsonian exhibit, "America on the Move." http://americanhistory. si.edu/onthemove.

"Vaudeville at Poli's Palace." http://tragedyandcomedyinnewengland. blogspot.com/2009/09/vaudeville-at-polis-palace-springfield.html.

Waterbury's Palace Theater. http://www.palacewaterbury.com/ newspaper%20article/article_1.htm.

Whitman, Edward C. "Submarine Heritage of Simon Lake." http://www. navy.mil/navydata/cno/n87/usw/issue_16/simonlake.html.

# ABOUT THE AUTHOR

Frank A. Juliano has been covering Milford for the *Connecticut Post* since 1995, back when the community was only 356 years old. He has also covered the towns of Trumbull, Newtown, Ansonia and Seymour and the cities of Derby, Waterbury and West Haven in a 30-year newspaper career. A 1978 graduate of Marquette University in Milwaukee, Wisconsin, Juliano received a master's degree in American studies from Fairfield University in 2009. He has been an adjunct professor of journalism at Southern Connecticut State University and has served on the board of directors of both the Milford Historical Society and the Milford Hall of Fame Committee.

*Photo by Nancy H. Juliano.*

Juliano has been a volunteer tutor at the Literacy Center of Milford and a mentor in the Bridges Across the Ages program. His novel, *Entr'acte*, was published in 2007. The author and his wife, Nancy, live in the Woodmont section of Milford with their beagles, Mazie and Lily.

Visit us at
www.historypress.net